SACRAMENTO'S
K STREET

WHERE OUR CITY WAS BORN

January 19, 2013

William Burg

Charleston · London
The History Press

Published by The History Press
Charleston, SC 29403
www.historypress.net

Copyright © 2012 by William Burg
All rights reserved

Cover image courtesy of the Center for Sacramento History.

First published 2012

Manufactured in the United States

ISBN 978.1.60949.425.4

Library of Congress CIP data applied for.

Notice: The information in this book is true and complete to the best of our knowledge. It is offered without guarantee on the part of the author or The History Press. The author and The History Press disclaim all liability in connection with the use of this book.

All rights reserved. No part of this book may be reproduced or transmitted in any form whatsoever without prior written permission from the publisher except in the case of brief quotations embodied in critical articles and reviews.

This book is dedicated to the memory of my grandmothers, Margie Signore and Blanche DeVita, and in memory of Douglas Yee, Sacramento historian and great-great-grandson of Sacramento pioneer Yee Fung Chung.

Contents

Acknowledgements 7
Introduction 9

Chapter One: Embarcadero 13
Chapter Two: Raising K 29
Chapter Three: Progress and Prosperity 48
Chapter Four: K Street Jazz 76
Chapter Five: The Sacramento Scramble 107
Chapter Six: The Shadow of the Alhambra 130

Notes 151
Index 157
About the Author 160

Acknowledgements

Most of the photographs in this book come from the Center for Sacramento History. Archivists Rebecca Crowther and Patricia Johnson were invaluable guides to the center's enormous photo collections. Sacramento's Central Library and its Sacramento Room were an equally valuable source for government documents, newspaper articles and out-of-print autobiographies that captured untold aspects of K Street's story. To librarians like Tom Tolley, James Scott and Amanda Graham, I owe a debt of gratitude and library late fees. The Western Railway Museum provided photographs of Sacramento's interurbans and streetcars.

Some material came from unpublished Sacramento State University master's theses, including the work of Barbara Lagomarsino, Clarence Caesar, Nathan Hallam, Robert Briggs and Brian Roberts. Graduate work often explores otherwise poorly documented areas of local history, but the end product is hidden in university basements. These works deserve greater review and study and are an underutilized resource for local history writers.

Sacramento State's connection with local history goes back to the university's founding. Many early faculty were charter members of Sacramento County Historical Society (SCHS). SCHS publications, such as *Golden Notes*, *Sacramento History Journal* and full-length book titles, approach local history from an academic perspective. Serving as an SCHS board member introduced me to an esteemed community of Sacramento historians and a closet full of digest-sized visits into Sacramento's past.

Acknowledgements

Many good friends shared their memories of K Street, including George Raya, Joy Gee, Leo and Maryellen Burns-Dabhagian, Mike Munson, Manuel Viera, Herbert Yee and Scott Soriano. Keith Burns, Dennis Newhall and Doug Taggart shared photos and documents from their private collections.

Introduction

J Street was a way out of town. K Street you always strolled.
—Maryellen Burns-Dabhagian

The scope of this book stretches, like K Street, from the birth of Sacramento at the river's edge to the demise of the theater that gave Alhambra Boulevard its name. The hotels, theaters, department stores, restaurants, dance halls, apartments, churches, offices, grocers and homes of K Street are all aspects of city culture. Immigrants and migrants came to cities like Sacramento, bringing diverse traditions. Through shared experiences like shopping, attending vaudeville shows and movies, parades and festivals, dancing, dining and working together, an American popular culture and urban identity formed. Some attempted to reinforce American values in place of foreign traditions, but urban life in cities like Sacramento was inevitably shaped by the cultures of its people.[1]

K Street begins at the Sacramento River and ends at Thirty-First Street, Sacramento's original city limit. Unlike J Street (the road out of town to the goldfields) or M Street/Capitol Avenue (the route over the river and to Folsom), K Street is a street that functions solely within Sacramento's urban core. Modern K Street is divided into segments. The westernmost segment is Old Sacramento, which stretches from the river to Second Street, where K Street is cut off from the rest of the city by Interstate 5 except for an underground walkway. The next is the semi-enclosed Downtown Plaza between Fourth and Seventh Streets and the former pedestrian mall

INTRODUCTION

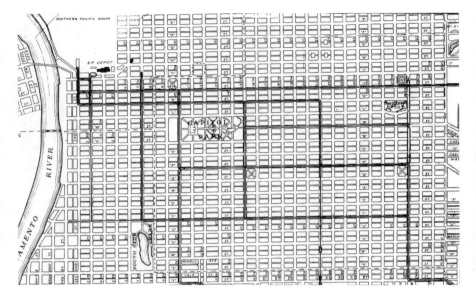

This 1936 map shows Sacramento's central city and streetcar lines. J and K Streets were both main streets, but J Street continued out of town while K Street stopped at the city limits. *Author's collection.*

between Seventh and Thirteenth, ending at the Sacramento Convention Center that physically blocks K Street. The third is part of what is now called Midtown, between Fifteenth Street and Business Route 80 at Twenty-Ninth Street. The final segment is the short stretch between Thirtieth Street and Alhambra Boulevard, where a fountain and a few palm trees are the only physical reminders of the Alhambra Theatre, on the edge of the East Sacramento neighborhood.

Some of these barriers are technically permeable to traffic, but they create mental boundaries that are hard to cross. Old Sacramento receives hundreds of thousands of visitors every year, but many never visit the remainder of downtown Sacramento across Interstate 5. Downtown and midtown Sacramento, despite their historic association as two halves of an urban whole, became divided as the business district expanded, and this expansion depopulated entire neighborhoods downtown. Residents of the central city sometimes treat the space between the highways and rivers as an island, refusing to leave the "grid" unless necessary. The boundary of Business Route 80 at Twenty-Ninth Street is equally daunting for many residents of Greater Sacramento, who seldom (or never) visit the central city.

Introduction

These barriers are not unique. They are common in most large American cities and bear the legacy of national trends in urban renewal, highway construction and suburban expansion.

The disconnection of K Street into unequal parts symbolizes the disconnection of Sacramento's urban history and its downtown neighborhoods from the pastoral legacy promoted by Sacramento's business community and Progressive era politicians. The story of K Street is the story of the conflict between these two very different histories. Redevelopment and suburbanization destroyed most of the physical evidence of Sacramento's industrial, immigrant and urban heritage, but enough remains in photographs, oral histories, newspaper accounts and government reports to provide an intriguing but incomplete look into the lives of the thousands who lived near K Street.

Because this story spans multiple lifetimes across all social classes, it is presented as a collection of short narratives, biographies, quotes and essays about the people, institutions, traditions and edifices found along K Street—all connected by the themes of struggle and celebration and their locations along the street where Sacramento was born. For many Sacramentans, their opinion of K Street reflects their opinion of Sacramento as a whole, whether in aspiration, nostalgia, appreciation or disgust. K Street was and is a place for transportation, entertainment, commerce, recreation, celebration, labor, residence or just a leisurely stroll. It is a street for the *flâneur*, those who walk in a city in order to experience it, not just to reach a specific destination. K Street's urban legacy is the shared territory of the *flâneur* and the historian.

Chapter One

Embarcadero

The land that became Sacramento was inhabited by the Nisenan (or Southern Maidu) for thousands of years. The town of *Sa'cum'ne*, or "Big Dance House," was located near the original confluence of the Sacramento and American Rivers, near the present-day site of Sacramento's city hall. The Sacramento Valley was a highly ordered cultural landscape, managed by direct human intervention. The Nisenan's deliberate use of fire and cultivation of important plants helped them to efficiently manage the bountiful but flood-prone plain, with defined areas of high ground used as retreats during winter months.[2]

The first nonnative visitor to the vicinity of K Street was probably New York–born mountain man Jedediah Smith. His 1826 trapping expedition from the Sacramento River to the site of Folsom prompted the Mexican government to name the river Smith's party followed the *Rio de los Americanos*, or "American River."[3] A later trapping expedition by the Hudson Bay Company in 1833, led by John Work, introduced another foreign visitor—a virulent malaria epidemic that killed an estimated twenty thousand natives by the end of the year. This plague was devastating to the indigenous people of California, who had no resistance to the diseases introduced by Europeans. Due to this act of unintentional germ warfare, the formerly densely populated communities of the Sacramento Valley were still reeling from the effects when the first European settlers arrived. John Sutter, a Swiss trader seeking a land grant from the Mexican government, picked a defensible spot of high ground for his settlement a few miles east of the

Sacramento River in 1839, near what is now the corner of Twenty-Seventh and K Streets.[4]

Sutter's decision was not accidental. A decade of trapping expeditions coming south from Oregon Territory established the land near the confluence of the Sacramento and American Rivers as a trading site between Russian, French and American traders and the Nisenan. Farther south in the Sacramento River Delta were the Miwok, more hostile to European incursions and better equipped to resist them but welcoming of traders. Sutter approached them as a trader but did not settle in Miwok territory. The confluence of the two rivers created a sandbar that limited passage of large ships farther north. This combination of transportation accessibility and potential trading partners, combined with the high ground necessary for defense against attack and flood, made the site ideal for a fort and trading post. Sutter returned to Monterey after his survey and indicated the site as his choice. Governor Alvarado, charged with encouraging inland settlement in *Alta California*, awarded the grant to Sutter as a way to bring a larger European population inland.

As a naturalized Mexican citizen, Sutter's land grant made him the ruler of Mexico's first inland settlement in California. The adobe fort served as a military base, trading post and, despite the Mexican government's wishes, an entry point for illegal emigrants from the United States. Sutter's power was based on the land grant, a lack of competition and his ability to dominate the Nisenan and play them against the neighboring Miwok. He introduced himself to his new neighbors with plentiful gifts but also demonstrated the power of his cannon. Sutter's combination of charm, fear and discipline turned the local Nisenan into his workforce, his soldiers and occasionally his merchandise. They were not technically slaves, but Sutter did give several Nisenan girls away as gifts to his neighbors. He also rented Nisenan laborers to other settlers, who then paid Sutter for their work.

Sutter's fort was a military encampment, trading post and production facility. The land the Nisenan cultivated for tule reeds and acorns was planted with grain and vegetables and was used to graze cattle, but agriculture was secondary to industrial production within the fort. Products like leather, blankets, clothing and baskets utilized the Nisenan's skills at handicrafts. These goods were traded for iron, which Sutter's blacksmith shops forged into tools that were sold to settlers. Grain and lumber mills increased Sutter's ability to convert natural resources and newly planted crops into marketable trade goods.[5]

Embarcadero

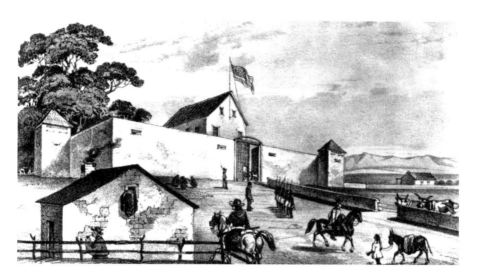

Sutter's Fort. *Center for Sacramento History.*

While European workers were paid in cash, the Nisenan workers were paid using tin discs that were punched with holes to represent a day's labor. This credit system kept the Nisenan economically dependent on Sutter because the discs could only be redeemed at his trading post. Observance of cultural tradition was not permitted if it interfered with Sutter's production schedules. Following a traditional dance that left his laborers too exhausted to work the next day, Sutter burned down their dance huts in reprisal. Through their labor, the Nisenan became the most valuable commodity in Sutter's growing economic empire. They produced the goods Sutter marketed to settlers and traders arriving from the north, east and downriver to Yerba Buena, the frontier settlement that later became San Francisco. Dressed in Russian uniforms purchased on credit, they also served as Sutter's army.

While settlers and sojourners often stopped at Sutter's Fort to trade and resupply, they seldom settled near the fort. In 1844, Sutter tried to promote settlement by laying out the town of Sutterville on a bluff along the Sacramento River, about three miles south of the American River. A path leading directly to the confluence of the two rivers was already established, but Sutter knew that this path was prone to flooding in winter and thus poorly suited as a town site. This path to the riverfront started near the sandbar at what is now the foot of I Street and extended to the front entrance of Sutter's fort (today near Twenty-Seventh and L Streets) and crossed the current site of K Street.

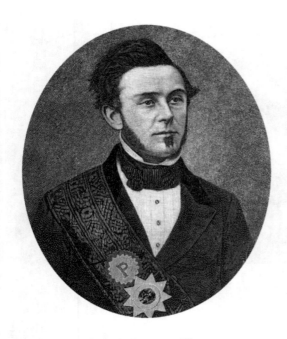

Sam Brannan. *Center for Sacramento History.*

Sutter and his Nisenan troops were captured while on a military expedition to Southern California in 1845, and by the time he returned to the fort, most of his Nisenan workforce was gone and a Miwok named Raphero led a rebellion against Sutter. Sutter captured and executed Raphero and displayed his head on a pike, an act that shocked and alienated the Miwok from Sutter. In 1846, the Mexican-American War brought California under United States control, and Colonel John C. Fremont took temporary command of the fort, renaming it Fort Sacramento. This political upheaval meant trouble for Sutter. Debts incurred from building and supplying the fort were overdue, and without his native workforce and unilateral control of his territory, he could not repay his creditors. Another of Sutter's projects, a water-powered sawmill on the American River, had even more disastrous consequences for his empire when his employee James Marshall found flakes of gold in the mill's tailrace. The coming gold rush spelled the end of Sutter's empire, and the soft adobe walls of his fort crumbled not long afterward.[6]

Sam Brannan, a Mormon trader from Maine, saw opportunity along the path of K Street. Arriving in California in 1846, he established a store at Sutter's Fort in 1847. Realizing a gold rush was coming after Marshall's discovery, he asked Sutter's land agent, Lanford Hastings, for free lots in Sutterville, Sutter's planned city southeast of the fort. Hastings refused, so Brannan set his tents just south of the American River sandbar, near the site of a river ferry owned by George McDougal, who also used his ferryboat as a general store. Other than the trail to the fort, there was no formal street layout, but Brannan's location was along Front Street, somewhere between I and K Streets' later locations. He may have realized the risk of flood but

considered it minimal compared to the coming flood of profits. Brannan's cries of "Gold! Gold, from the American River!" through the streets of San Francisco in May 1848, shortly after buying every digging implement he could find, marked the start of the California gold rush. Sutter's embarcadero was closer to the gold country than Sutterville and on the already established trade route, so the first wave of gold-seekers left the river at the front door of Brannan's new store. The relatively dry winter of 1848–49, as well as the enormous profits from the sale of hardware and supplies to the first wave of miners, inspired Brannan to establish the area as a permanent settlement.[7]

Sutter's mounting debts and circling creditors led him to transfer his property to John Sutter Jr., his son who had recently arrived from Switzerland, while Sutter Sr. departed for the foothills in search of gold. Sutter Jr. was twenty years old and spoke little English. Brannan proposed a way for Sutter Jr. to solve his father's debt problems by subdividing and selling lots in a new settlement, Sacramento City, on the land between the fort and the Sacramento River. They hired recently arrived lawyer Peter Burnett to act as land agent. Captain William Warner of the Army Corps of Engineers, assisted by Lieutenants William Tecumseh Sherman and O.C.E. Ord, was hired to lay out a city plan in the fall of 1848. The blocks were 320 feet east–west by 340 feet north–south, including a 20-foot-wide alley with 80-foot-wide streets (except for M Street, which is 100 feet wide) and an extra 80 feet in the block between Twelfth and Thirteenth Streets. The north–south streets were numbered and the east–west streets were lettered. The first lots were auctioned off on January 8, 1849, although Brannan's building on Front Street between J and K was already under construction by that date.[8]

Brannan understood that whoever controlled the waterfront of the new city of Sacramento had an enormous economic advantage. The ferryboat operator, George McDougal, claimed his lease from John Sutter Sr. covered the entire waterfront, but Brannan convinced John Jr. to challenge the lease in court. McDougal lost his claim and moved to Sutterville, then lowered his prices to compete directly with Brannan. Brannan responded with sabotage, destroying McDougal's stock. Brannan also made an offer to Sutterville land agent Lanford Hastings to relocate his store to Sutterville in exchange for 80 lots of free land. Hastings accepted, hoping to capture Sacramento's business, but Brannan went directly to Sutter Jr. and asked for a counteroffer to keep him in Sacramento. Sutter Jr. gave Brannan 500 city lots in return for a promise to stay in Sacramento. McDougal went to John Sutter Sr. to seek relief. Sutter left his winter camp at Coloma in a desperate effort

to salvage what was left of his grant, but in the end all he could do was fire Peter Burnett. Because Sutter did not have enough money to pay the lawyer's fee as his land agent, Burnett was paid in lots of Sacramento land. By early 1849, McDougal, Lanford Hastings, Sutter and his son and the vision of Sutterville had been defeated. The first city charter was approved by voters in October 1849, approved by the state legislature on February 27, 1850, and formally incorporated on March 18, 1850.[9] The Sacramento City settlement became the city of Sacramento.

Terminus on K Street

In 1849, the Sacramento River levee at the foot of K Street was the arrival point for Argonauts seeking gold on the banks of the American River. As news of the gold rush reached the East Coast and the rest of the world, hundreds of thousands poured in via the Golden Gate and continued up the Sacramento River to the new city's doorstep. Sacramento's central location and river access for large sailing ships made it the busiest inland port in the state. Travelers stepping off the gangplanks at the foot of K Street were met with a row of hardware stores, grocers, hotels, gambling dens and taverns. Ships abandoned by gold-hungry crews became floating warehouses for Sacramento merchants called "storeships." By May 1850, thirty-three storeships were permanently moored at the levee. The riverfront businesses

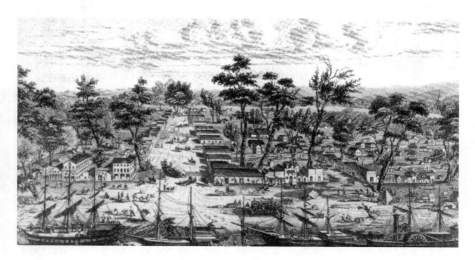

Sacramento's waterfront in 1850. *Center for Sacramento History.*

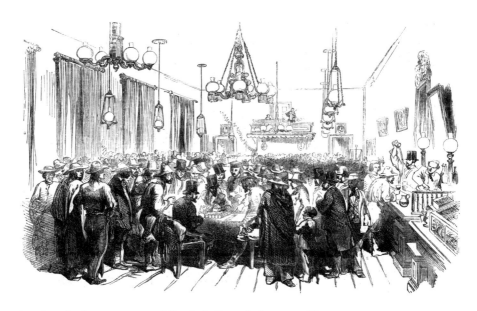

Interior of a Sacramento gambling hall. *Center for Sacramento History.*

equipped and refreshed new arrivals and provided a provisioning center and recreation area for those returning from the goldfields.

The first steamboat to operate on the Sacramento River was the *Sitka*, a boat so slow that on its inaugural voyage several passengers disembarked to continue on foot and actually beat the *Sitka* to San Francisco Bay. By 1850, large steam-powered side-wheeler steamboats worked between San Francisco and Sacramento, including the *Senator*, *New World*, *Wilson G. Hunt* and *Antelope*. A multitude of smaller steamboats, including the *Governor Dana* and *Young America*, worked farther north and in tributaries of the Sacramento River as far as Marysville and Red Bluff, where the large boats could not go.[10] By 1854, the California Steam Navigation Company had gained a controlling interest in river traffic between Sacramento and San Francisco, with a permanent riverfront dock established at the foot of K Street.

The first stagecoach service in Sacramento was inaugurated in 1849 by James E. Burch of New England, who charged two ounces of gold dust (worth $3,000 in today's currency) for a trip from the foot of K Street in Sacramento to Coloma, a trip of about fifty miles. J Street rapidly became the route to the goldfields, used by miners on foot and the newly inaugurated stagecoach and drayage wagons, but the foot of K Street, the point where passengers disembarked from riverboats, became the hub of California's new stagecoach

network. Like the riverboat crews who carried passengers rather than abandon their craft at the Sacramento waterfront, these frontier capitalists decided gold was easier to obtain via the miners than directly from the river.[11] In July 1852, the Wells Fargo Express Company opened its first offices in Sacramento and San Francisco simultaneously, connected by riverboat. San Francisco was the blue-water port and emerging financial center, but Sacramento was the crossroads of transportation and trade. The office at Front and J Street was a block from the K Street embarcadero.

Sacramento in the 1850s:
Flood, Riot, Cholera, Fire and More Floods

John Sutter placed his fort on high ground several miles from the river to avoid flooding problems.[12] Sam Brannan's decision to locate Sacramento next to the river was a decision for short-term gain, but it had long-term consequences for the new city. Many new Sacramentans believed Brannan's claims that the area was not subject to flood and were caught by surprise when the Sacramento River overran its banks through the new city in January 1850. In response to the flood, Sacramento businessman Hardin Bigelow urged the new city council to build a short levee from the American River, just north of the city, and three miles to the south, near Sutterville. Dissatisfied with the city's response to the plan, Bigelow hired a work crew and constructed the levee on his own. While his project was underway, Bigelow was elected Sacramento's first mayor, and shortly after his election, the levee was officially authorized.[13]

Bigelow's administration was cut short by the Squatter's Riot in August 1850. Property owners and speculators who purchased official city lots came into conflict with settlers who argued Sutter's Mexican land grant was invalid, allowing them to occupy vacant land without a deed. The riot ended months of escalating debate, legal battles, assaults and arrests (including that of future *Sacramento Bee* founder, James McClatchy) between the Settler's Association, representing the squatters, and the city's common council, representing holders of Sutter deeds. On August 12, Mayor Bigelow and Sacramento sheriff Charles Robinson moved to evict a squatter, but Mexican War veteran John Maloney and a force of fifty armed men stood in their way. Mayor Bigelow called out to the public to take up arms. Two large armed mobs met at Fourth and J Streets, one supporting the squatters, the other, the speculators.

Embarcadero

The standoff was broken when Maloney shouted, "Shoot the Mayor; shoot the Mayor!" Both sides exchanged gunfire, killing four men and wounding five, including Mayor Bigelow, who was shot four times but not killed. Bigelow's injuries were so serious that he was moved to San Francisco, where he died of cholera in October. This outbreak of cholera spread to Sacramento that same month, transmitted by a passenger on the riverboat *New World*.

The city flooded again in 1851, 1852 and 1853. After four years of regular floods, Sacramento property owners agreed to pay to elevate the city streets. This brought the city's elevation up one to five feet, using Plaza Park at Tenth and J Streets as a baseline. Buildings in the raised district raised their street-side entrances by three to four feet to meet the new level of the sidewalks. Combined with levee improvements, this early street-raising project cost approximately $200,000 and kept Sacramento relatively dry through the remainder of the 1850s.[14]

Each time Sacramento flooded, Sacramentans temporarily moved east about four miles, near the vicinity of present-day Sacramento State University. During the 1850 flood, this high ground was called New Sacramento; it was called Hoboken in 1853 and, in the 1852 flood, property owner Sam Norris modestly named it Norristown.[15] Each time floodwaters receded from Sacramento's city site, the settlers returned from high ground to rebuild by the river. While the flood risk was undeniable, Sacramento was simply too valuable as a center of commerce to abandon. Its critical location outweighed the hazards. Sacramento had already become the second largest city in California, with thirteen thousand residents, a growing network of riverboats and wagon roads to the gold country and smaller towns throughout the valley. Proximity to the Sacramento River also linked the town to San Francisco and the Pacific coast. Sacramento's location may not have made sense, but it did make money.

On November 2, 1852, another disaster struck. A fire started in Madame Lanos's millinery shop on the north side of J Street at Fourth Street and spread to adjoining buildings. Sacramento was particularly vulnerable to fire, as most construction was of wood and canvas, with only a few brick buildings. Dry weather and strong winds blew burning coals to the southeast. In less than ten minutes, the fire had spread a block south to K Street. Sacramento's handful of fledgling fire companies were rapidly overwhelmed by the scale and size of the fire. The final path of the fire destroyed everything on J Street east toward Ninth Street, and on K Street the devastation spread to Twelfth on both sides of the street.

On the following morning, survivors and salvaged property were crowded on the Front Street levee. Steamboats and stagecoaches dispatched in all directions from K Street summoned help. Within two days, citizens of Marysville started gathering donations for a relief effort, and performers in San Francisco arranged benefit concerts to raise repair funds. Lumber and even ready-made houses were loaded onto riverboats and barges for shipment. The massive demand for wood caused a dramatic spike in lumber prices. Rumors spread that speculators had raced to San Francisco to buy up stocks of lumber before news of the fire had even arrived, hoping to sell the lumber at a quick profit. Within a month, reconstruction of Sacramento was already underway, and some property owners used brick as a more fireproof alternative.

Sacramentans redoubled their efforts to build a city that would endure future disaster, including another flood on New Year's Day 1853, less than two months after the fire. These efforts also included fire protection, including water cisterns on J and K Streets and two new volunteer fire companies. In order to supply these cisterns and the fire departments, a plan for a new city waterworks was needed. The citizens of Sacramento approved a tax to pay for a waterworks but rejected both of the proposed plans to build one, so the city council prepared its own plan for a municipal waterworks constructed at Front and I Streets, completed on April 1, 1854.[16] K Street was also paved for the first time in 1853, using planks of Oregon fir and California pine; the paving stretched from the river to Eighth Street.

THE EARLY K STREET BUSINESSMEN:
CROCKER, STANFORD, HOPKINS AND HUNTINGTON

Charles Crocker arrived in California in 1850 from New York with his brothers Clark and Henry, establishing a store in an El Dorado County mining camp. Charles's job was driving freight wagons from the K Street dock to their store. This venture was successful, and by 1852, they decided to open a store in Sacramento at 246 J Street and were joined by their older brother, Edwin. Shortly after opening, this location was destroyed in the great 1852 fire. Fortunately for the Crocker brothers, Charles had traveled back to the East Coast to marry and returned with a large shipment of merchandise in March 1853, just in time for reconstruction of the store and profitable sales to others rebuilding in the wake of fire and flood.

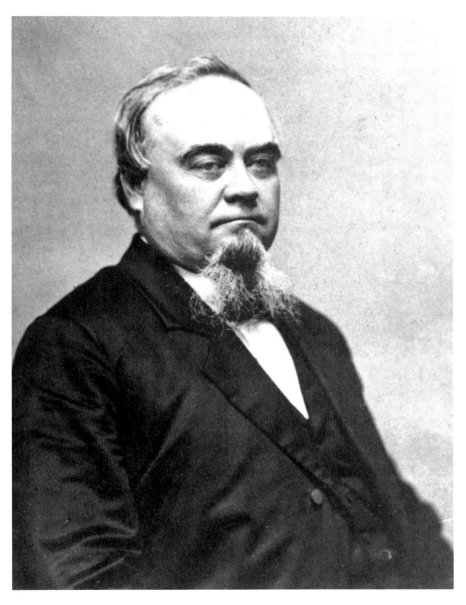

Edwin Bryant Crocker, pioneer Sacramento businessman and civil rights attorney. *Center for Sacramento History.*

The rebuilt Crocker store combined dry goods downstairs and residences for Charles, Edwin and their wives upstairs. Edwin, who had worked as an attorney in the Crockers' home state of New York, was admitted to the state bar and established the law firm of Crocker, McKune and Robinson in 1854. As the 1850s progressed and Sacramento was spared natural disasters for a few years, Charles's dry goods business prospered, and Edwin pursued other interests, including gardening and viticulture. Edwin established the Sacramento Music Society in 1856 and served as its first president. He was also active in politics and the abolitionist movement. In New York, he had belonged to the antislavery Liberty Party and defended an escaped slave in Indiana in 1850. In 1856, he joined the fledgling Republican Party, whose platform opposed slavery and supported California pathfinder John C. Fremont as its presidential candidate. Edwin led the first Republican Party meeting on April 19, 1856. He also convinced his brother Charles to join, and through the Republicans, the Crockers met three other Sacramento businessmen: Leland Stanford, Mark Hopkins and Collis P. Huntington.[17]

While California was nominally a free state, slavery was a contentious political issue. Early Republican assemblies were disrupted by Cavalier Democrats, supporters of slavery in the southern United States, and representatives of the Native American (or "Know-Nothing") Party. Many Southern Democrats, or Cavaliers, were interested in splitting California into two states, with "South California" as a slave state. The "Know-Nothings" opposed all immigration, including Catholics from Europe, and were powerful enough to elect their candidate, J. Neely Johnson, as California's governor in 1856. Both groups opposed the Republicans' pro-immigrant, antislavery stance, but some members of the so-called Tammany wing of the Democrats, aligned with Northern interests, were attracted to the new party. Another plank of the new Republican Party was a transcontinental railroad to reach California.[18]

Leland Stanford arrived in California in 1852, joining his brother Josiah, who came west in 1850, followed by another brother, Phillip. Like the Crockers, the Stanfords started with small shops in the mining camps but shifted their operations to Sacramento, where their businesses flourished. The Stanford store specialized in groceries and fresh produce and was located on L Street. When Josiah and Phillip opened an office in San Francisco, Leland took over the Sacramento store and distribution to outlying communities. In 1855, Leland briefly returned home to Albany, New York, originally intending to stay on the East Coast. His wife, Jane, expressed her dissatisfaction with Albany life in his absence, claiming that

Embarcadero

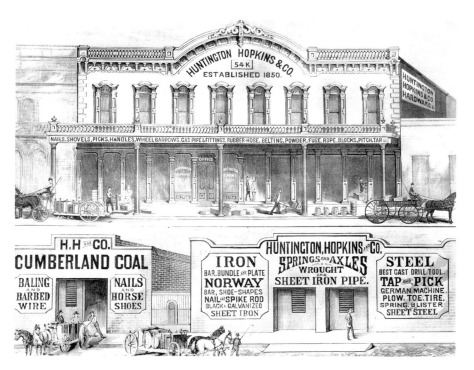

Huntington-Hopkins Hardware, 54 K Street. *Center for Sacramento History*.

those in her social circle assumed he had abandoned her and treated her accordingly. Stanford returned to Sacramento shortly thereafter, bringing Jane with him.

In between the Crocker and Stanford stores on J and L Street was the Hopkins-Huntington Hardware Store at 54 K Street. Mark Hopkins and Collis P. Huntington came from New York to California separately, and like Crocker and Stanford, they had little interest in gold mining. At thirty-five years old, Mark Hopkins was considered an old man at the time of his arrival in California, where most gold-seekers were much younger men. He quickly made his reputation as a quiet, skilled accountant and bookkeeper, respected for his wisdom and earning the nickname "Uncle Mark." Collis P. Huntington's trading acumen was already proved by the time he arrived in California in the spring of 1850. On the journey to California, he increased his starting capital from $1,200 to $5,000 by trading with other passengers. Huntington and Hopkins specialized in hardware due to Huntington's preference for non-perishable goods that could be stored while prices were low and sold when they were high. Number 54 K Street became the

center for local business ventures that expanded the foot of K Street from a regional transportation hub to the connecting point for continent-spanning communication and transportation empires.[19]

California's First Railroad and K Street

The Sacramento Valley Railroad (SVRR), the first steam railroad in the western United States, started construction in 1854 and was completed in 1856. The railroad was financed by Charles Lincoln Wilson of San Francisco, whose transportation empire also included riverboats on the Sacramento River and plank roads in San Francisco. Engineer Theodore Judah was solicited by Wilson to design the railroad. Its route stretched twenty-two miles from Sacramento to the city of Folsom. Judah had bigger dreams in mind for the railroad, imagining it as the first link in a transcontinental route. By 1860, SVRR had extended its Sacramento terminus from Front and R Streets to Front and K Streets. The SVRR had immediate consequences for K Street, as the speed and efficiency of railroad travel meant stagecoach and freight wagon traffic shifted from Sacramento to Folsom. The SVRR was originally intended to serve the goldfields along the American River, but by the mid-1850s, the gold rush was already slowing down. The fledgling railroad received a large economic boost when the Comstock Lode, an enormous silver strike in Nevada, started another economic boom. Wilson's railroad sped the flow of materials, men and money from the Nevada silver mines to San Francisco via the Sacramento waterfront. The original terminus for the SVRR in Sacramento was at Second and R Streets, but by 1860, it had established a new passenger depot just south of K Street along the river levee. This pioneer railroad placed Sacramento in a critical location between the growing metropolis of San Francisco and the mineral resources that sent wealth to the bay, bringing more wealth and development to Sacramento, California's second largest city and, in 1854, its new capitol.[20]

Fighting Slavery on K Street:
The Story of Archy Lee

In 1857, Sacramento became the site of a court battle between an escaped slave, Archy Lee, and his former owner. California law prior to the Civil War did not permit slavery for permanent residents, but slave-owning sojourners

temporarily in California were allowed to keep them. With the help of Sacramento's small but politically active African American community, Archy challenged this rule and gained his freedom. The resulting struggle was an early victory in American civil rights that began on K Street.

Archy Lee was born a slave in Mississippi and was brought to Sacramento by Charles Stovall. They arrived in Sacramento on October 2, 1857. During his stay in Sacramento, Lee met Charles Hackett and Charles W. Parker, the African American owners of the Hackett House Hotel at the corner of Third and K Streets. Hackett House was the center of Sacramento's small but politically organized African American community. In a state where most whites were divided between those who wanted to exclude nonwhites entirely and those who wanted California to become a slave state, the black community's need for organization was obvious. By 1857, they had established two churches, St. Andrew's African Methodist Episcopal in 1850 and Siloam Baptist Church in 1856. They also established a public school and several local businesses and hosted statewide "Colored Convention" events to advocate for civil rights.

In January 1858, Stovall decided to return to Mississippi. Lee resisted by taking refuge at Hackett House. Stovall sought assistance from the Sacramento County sheriff and had Lee arrested. Shortly after Archy's arrest, Charles Parker of Hackett House approached Edwin Crocker's law firm to defend Archy. Crocker and his partner, John McKane, accepted the case.

The decision of Judge Robert Robinson on January 26, 1858, was that Archy was a free man because Stovall was a permanent resident of California and thus could not own slaves. However, Stovall arranged for a second arrest warrant by appealing to the state's Supreme Court, and Lee found himself before another judge. In 1858, California's Supreme Court was located in the Jansen Building at Fourth and J Streets, just over a block from Hackett House.

State Supreme Court justice Peter Burnett, formerly John Sutter Jr.'s land agent and California's first elected governor, was also an ardent racist. While a member of the Oregon legislature before moving to California, he authored a bill banning African Americans from the state, punishing those who chose to remain by flogging them every six months. While governor of California, he attempted to pass a bill banning them from California entirely, whether slave or free. On February 11, 1858, Judge Burnett handed down a very unusual decision, supported by fellow Supreme Court justice David Terry (a Southern Democrat who fled the state the following year after killing antislavery advocate David Broderick in a duel). While California law prohibited slave ownership

for state residents, Burnett decided that Stovall's inexperience and poor health was sufficient reason to grant him leniency. Thus, in his opinion, Lee was Stovall's property and had to leave California with him.

Most Californians, especially in the African American community, were outraged by the absurdity of this decision. On March 5, Stovall tried to sneak Lee out of California on the ship *Orizaba* but was stopped by representatives of the Colored Convention. This time, both Lee and Stovall were taken into custody, Lee for safekeeping and Stovall for holding a slave illegally.

Two more trials awaited Archy Lee. In March, abolitionists and African Americans assembled another team of attorneys, and Judge Thomas W. Freelon of the San Francisco district court overturned Burnett's decision. Stovall made a final plea to United States commissioner William Penn Johnston, a Southerner, arguing that Lee was in violation of the 1850 National Fugitive Slave Law. They hoped that Johnston's status as a federal official would trump California state law. Lee's San Francisco attorney, Edwin T. Baker, argued that since Lee had attempted to escape Stovall's bondage while in California, no state lines were crossed and thus no federal case could be established. Johnston agreed, and on April 14, 1858, Archy Lee was declared a free man.

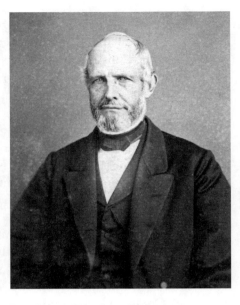

Peter Burnett, John Sutter Jr.'s land agent, California's first elected governor and Supreme Court justice during the Archy Lee case. *Center for Sacramento History.*

Lee joined an expedition of African Americans resettling in Victoria, British Columbia, but later returned to California. In 1873, several newspapers in San Francisco and Sacramento reported that Lee was found ill near the bank of the American River and was taken to the county hospital, where he died. Lee's victory created a legal precedent that helped others escape slavery and promoted the abolitionist cause in Sacramento, via institutions like Hackett House and antislavery attorneys like Edwin Crocker.[21]

CHAPTER TWO

RAISING K

Sacramento was a center for ranches and mines. Lying in an angle of the Sacramento and the American Rivers, the town was the heart of the life, the trade and the vice of the great valley of wheat and cattle ranches, of the placer mining of the foothills, of the steamboat traffic with San Francisco, and, by the new railroad, with the world beyond. I remember seeing the mule teams ringing into town, trains of four or five huge, high wagons, hauled by from twelve to twenty and more belled mules and horses driven by one man, who sometimes walked, sometimes rode the saddled near wheel-horse. Cowboys, mostly Mexicans and called vaqueros, used to come shouting on bucking bunches of broncos into town to mix with the teamsters, miners, and steamboat men in the drinking, gambling, girling, fighting of those days.
—*Lincoln Steffens,* The Autobiography of Lincoln Steffens

On December 9, 1861, the American River overflowed the levee at Smith Gardens, in the vicinity of what later became Elvas Avenue, and the city of Sacramento flooded from the north. The Sacramento Valley Railroad levee on R Street, on the southern end of the city, was intended to prevent flooding from the south and keep trains above flood level. Because the levee break at Smith Gardens was upstream from the city, the floodwaters filled Sacramento and were stopped from draining downstream by the R Street railroad levee that carried the Sacramento Valley Railroad. Sacramento was inundated until a hole was punched in the levee. This flood was more damaging than earlier floods, and Sacramento's existence was again at risk.[22] Newspapers throughout the state called for the relocation of the state capital, and yet

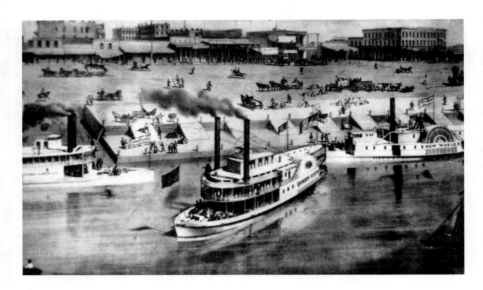

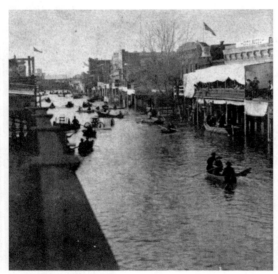

Above: Sacramento waterfront circa 1855–60. *Center for Sacramento History.*

Left: K Street at Fourth during the flood of 1861–62. *Center for Sacramento History.*

another high-water settlement called New Sacramento was established on the Sam Norris Ranch, near the earlier settlement of Hoboken, anticipating the abandonment of the city.[23]

In 1862, as damage from the previous winter's flood was being repaired, city leaders decided a second street raising was necessary. This project included J, K and L Streets, from the embarcadero on

Raising K

Front Street to Twelfth Street. In order to bring the city well above high water, estimated at twenty-four inches above the high-water mark of the Sacramento River, streets were raised ten to twelve feet. Reinforced brick walls lined the streets, and the spaces between the walls were filled with dirt. Buttresses behind the walls provided strength to prevent the walls' collapse. The space between the edge of the street and the building itself, formerly the sidewalk, was the responsibility of building owners, as was the decision to raise or bury individual buildings. Advocates of this new, higher street level were called "high-graders," while proponents of levee construction instead of further street raising were called "low-graders." The Sacramento Board of Trustees included two high-graders, H.T. Holmes and Josiah Johnson, and one low-grader, C.H. Swift. Swift was outvoted, and the high-graders' plan went forward. To carry out this work, the board of trustees hired the local brickmaking firm of Turton, Knox and Ryan.[24]

Buildings could be raised to the new street level by hiring a contractor to elevate the building on hundreds of screw jacks. This process usually took several weeks and had its own risks. Several buildings not strong enough to handle the strain collapsed while being jacked up. If the building was successfully raised, a basement level was built under the building and the jacks removed. Wooden planks were used to create a sidewalk from the edge of the building to the street wall.

Street raising was only part of the long-term solution to flooding in Sacramento. Between 1862 and 1868, the mouth of the American River was moved approximately one mile north in a massive excavation project. The canal ran roughly parallel to Sacramento's northern city limit, eliminating two sharp bends in the river that were the most likely points for flooding. This project turned the old river mouth at I Street into a small, swampy lake called Sutter Lake or China Slough. This slough was deeded to the Central Pacific Railroad for use as its railroad shops on the condition that it fill the slough, a project that took over forty years. Much of the dirt excavated from the new river channel was hauled downtown and used as fill dirt for the street-raising project.[25]

In 1867, another flood year, Sacramento flooded in many sections not yet raised to the new grade, and the California Assembly proposed another bill to relocate the capital. However, by this time it was clear that high-grading was working. In 1872, Plaza Park at Tenth and J was raised to the new grade. By 1876, the street raising was complete, and K Street remained above water even in years of heavy rains.[26] The high-graders and their street-raising

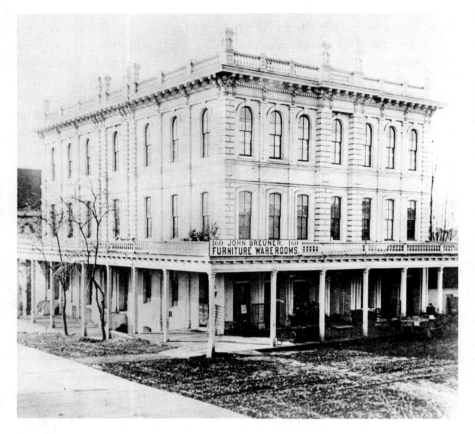

Founded by John Breuner in Sacramento in 1856, Breuner's Home Furnishings was located at Sixth and K Streets. John Breuner came to the United States from Germany in 1849, arriving in California in 1852. Later, Breuner's stores were located in Oakland, San Francisco and eventually throughout California and Nevada. *Center for Sacramento History.*

project saved the city from floods and probably prevented loss of the state capital or even abandonment of the city.

At first, the newly raised streets were simply filled with dirt, but these dirt streets turned to enormous mud pits in rainy weather. To limit mud, the new elevated streets were dressed with gravel. From 1867 to 1872, many downtown streets were paved with a composite material called Nicolson pavement, wooden blocks coated with tar. The wooden blocks were quieter and smoother than gravel or cobblestone but were not very durable due to the untreated wood's direct contact with soil. By 1875, K Street had been repaved with granite cobblestones.

Raising K

Sacramento's Chinatown: Yee Fow

Chinese immigration to California is often associated with the draw of the gold rush, but it was also driven by economic instability in China after a series of trade wars with England. The promise of *Gum Saan* ("Gold Mountain") drew about ten thousand Chinese laborers to California, motivated by hunger and desperation more than greed. Political instability during the Taiping Rebellion of 1851–64 also motivated Chinese to leave their home country for an uncertain future in California.[27]

Chinese immigrants to California faced enormous challenges and obstacles upon their arrival, including efforts to exclude or remove them from California entirely. The earliest days of Chinese immigration to California were prior to the end of slavery in the United States, and some Southern migrants to California saw Chinese laborers as de facto slaves. While nominally free under the California constitution, which forbade slavery in name, many Chinese arrived under contracts that turned them into indentured servants with legal statuses little better than those of slaves. White miners in California fought an 1852 "Coolie" bill (a derogatory term for Chinese workers derived from *Ku Li*, meaning "bitter strength") that would have formalized Chinese indentured servitude as a legal "unfree" status. This opposition was based on resistance to the presence of the Chinese as a low-cost workforce, not out of concern for the Chinese workers' well-being.[28]

Most of Sacramento's early Chinese population came from the southern Chinese province of Guangdong. The journey from China to California was generally overcrowded and overpriced, ending at San Francisco at a *hui kan* ("district association") for a brief respite before taking a riverboat

Yee Fow, Sacramento's Chinatown, was built along I Street at the river levee. The building with the flag in the background is Sacramento's original state capitol building at Seventh and I Streets. *Center for Sacramento History.*

to Sacramento. By 1851, Sacramento had its own three *hui kan* along I Street. By the mid-1850s, the area had two new names. European settlers called the new district Chinadom, or Chinatown, and started calling the river confluence China Slough. The Chinese called it *Yee Fow*, or "Second City," second to San Francisco's Chinatown, *Dai Fow*, or "Big City." The 1850 census listed only eight Chinese in Sacramento, but by 1852, Yee Fow had a population of approximately 600–800, nearly 10 percent of the city's population.

California passed a Foreign Miner's Tax in 1852, requiring all foreign-born miners in California to pay three dollars a month (when most miners made about six dollars per month) that shut many Chinese out of the gold fields. Robbery, fraud and attacks on Chinese miners were common. The same California Supreme Court decision (*People v. Hall*) that prevented African Americans from testifying against whites also applied to Chinese, so Chinese miners robbed or attacked by whites had no access to justice. Many Chinese miners persevered despite these risks and obstacles. But as businessmen like Sam Brannan had already discovered, there were ways to make money in California besides mining. By selling goods and services to miners, the new settlers could make money without paying the unfair tax. Instead of marketing their goods strictly to other Chinese, these immigrant merchants expanded their markets and earned through trade the gold they were denied in the goldfields. Other Chinese saw opportunity in California's fertile soil and took up farming. They shipped their products to Sacramento to be sold by Yee Fow merchants.

Migration to California during the gold rush was overwhelmingly male. While this changed over time for migrants of European ancestry, immigration of Chinese women was far more limited. In 1860, 808 Chinese men lived in Sacramento, but there were only 180 women. As a consequence, birthrates were low, and by 1870, only 31 of Sacramento County's 3,598 Chinese were American-born. As California passed laws limiting Chinese immigration, the Chinese population of Sacramento dropped to 1,065 by 1900, down from 1,781 in 1880.[29]

In 1875, the United States Congress passed the Page Act, prohibiting the immigration of any Chinese woman who was not a merchant's wife. Purportedly to prevent the importation of Chinese women for prostitution, this gender imbalance contributed to the low birthrate. Many Chinese women who might have migrated to California voluntarily were deterred by fears of being forced into prostitution upon their arrival, as this was the fate of many early female Chinese immigrants. As a result, only about 4 percent

Raising K

The Chinese settlement that abutted Sutter Lake, also called China Slough. The area was undesirable to white settlers, so the early Chinese settlers built where they could, alongside and even over the slough. Some of these households started laundry businesses and used the slough as an impromptu water supply and washbasin for their customers' garments. Note the railroad levee in the background. *Center for Sacramento History.*

of Chinese in the United States were women. Sacramento County's Chinese population was about 20 percent women, relatively high in comparison.[30]

The anti-Chinese movement in California meant limited access to education, economic opportunity and citizenship for Chinese immigrants. Labor unions were among the most vocal anti-Chinese activists, while large businesses seeking inexpensive labor opposed anti-Chinese legislation. In both cases, the deciding factor was their perspective of the Chinese as a low-cost labor force. The Chinese Exclusion Law of 1882 forbade Chinese laborers from entering California for ten years, extended another ten years in 1892 by the Geary Act and then indefinitely extended in 1904. The 1888 Scott Act prohibited reentry of Chinese laborers to the United States if they left the country.[31]

Some immigrants found ways around these restrictive laws, including falsified documents identifying the bearer as a merchant and thus exempting him from the exclusion law. An 1898 court case upheld birthright citizenship for American-born Chinese, allowing children of American citizens born in China (or born in the United States and brought back to China) entry into the United States as "derivative citizens." This created a black market for papers identifying an immigrant as the child of

This Chinese Baptist Chapel at Sixth and H Streets was also the founding site of the Siloam Baptist Church, one of two gold rush–era African American congregations in Sacramento. *Center for Sacramento History.*

an American citizen, called "paper sons" (and paper daughters). The 1906 San Francisco earthquake and fire destroyed many records, creating more opportunities for this method of immigration. In the 1950s, the United States offered amnesty for thousands of Chinese immigrants brought to the United States by this method.[32]

According to historian Lawrence Tom, Sacramento's Chinatown was different than other Chinatowns: "It was possible for a resident to live a lifetime in San Francisco's Chinatown without going beyond its boundaries." While Sacramento's Chinese population faced the same issues of racism and political and economic exclusion as other Chinese in the United States, their Chinatown was more open and fluid. Residents could more readily interact across racial lines, and many Chinese businessmen were able to establish themselves in the larger community. Sacramento was not large

enough for ethnic enclaves like Yee Fow to become as economically and socially independent as San Francisco's Chinatown. However, Sacramento's Chinese population was too large to ignore, exclude or drive away, unlike those of smaller California cities. This middle ground allowed inroads for Sacramento's Chinese into the larger city economy.[33]

Yee Fow also set the pattern for other ethnic communities within Sacramento. Subsequent generations of immigrants and migrants came to Sacramento, bringing their traditions, skills and culture and establishing their own neighborhoods. The boundaries of these communities were often defined by barriers like religion and language and were limited by prejudice and racism, but all became part of Sacramento's overall economy and cultural life. The immigrant generation struggled to establish a community that maintained their traditions and ensured a better life for their children. The Sacramento-born children of these communities carried on those traditions and embraced American culture as a way to find acceptance in a country that did not always recognize them as fellow Americans.

The merchants and workers of Yee Fow also shared the legacy of the early pioneer merchants, like the Crockers, Stanford, Huntington and Hopkins. They, too, fought the fires and floods that ravaged early Sacramento, established businesses to take advantage of Sacramento's strategic location and, like Sacramento's early African American community, were disenfranchised by laws that forbade legal testimony by nonwhites and excluded them from economic opportunity and property ownership. Their legacy also included thousands of railroad workers, whose labor created the greatest engineering project of the nineteenth century, starting at the foot of K Street.

Yee Fung Chung, Sacramento Pioneer

According to family oral tradition, Yee Fung Chung came to Sacramento during the gold rush but continued east to the gold-mining settlement of Fiddletown, where he established his first business in America. In 1862, Jane Stanford, the wife of Sacramento businessman and California governor Leland Stanford, became sick. Stanford sought out Yee Fung Chung at the insistence of his Chinese cook, and the restorative powers of Mr. Yee's herbal medicine restored Mrs. Stanford to health.

After moving to Virginia City, Nevada, in 1869, he began using his second birth name, Wah Hing, a name he utilized until returning to Sacramento.

The exact date of his return is unknown, but advertisements for his business at 1209 Third Street, under the name Yee Wah Hing, appeared in 1901, and he opened an office at 725 J Street in 1905. His son, Yee Lok Sam, adopted the name T. Wah Hing in about 1897, continuing his father's business on Third Street, but he reassumed the name Yee Lok Sam in 1910. Yee Lok Sam's son Henry grew up in the United States and later continued the family tradition of herbal medicine at another office on J Street.[34]

THE CENTRAL PACIFIC RAILROAD BEGINS ON K STREET

A Pacific railroad to connect California to the rest of the nation by rail was a hotly debated subject in the 1850s. Every city on the West Coast made its case for why it was the best and most natural location for a western terminus from Seattle to San Diego. Political wrangling over the railroad's route was settled with the outbreak of the Civil War and secession of Southern states. Sacramento's connection to the new Republican president Abraham Lincoln gave the capital city a competitive edge over its larger rival San Francisco. Leland Stanford, who won the California governorship the same year Lincoln became president, was instrumental in winning California for the Republicans. Stanford's friends Hopkins, Huntington and the Crockers,

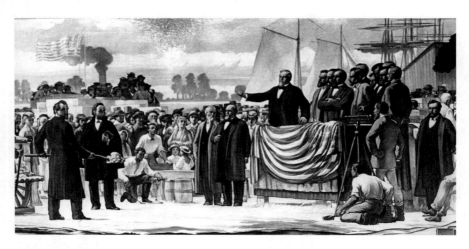

Groundbreaking for the Central Pacific Railroad took place on January 8, 1863, at the foot of K Street. Holding the shovel is Leland Stanford; Charles Crocker is on the podium. To the left of the podium are Mark Hopkins and Collis P. Huntington. On the far right is Theodore Judah. *Center for Sacramento History.*

all Republican Party representatives, used their political connections to pursue a contract for a Pacific railroad.

Central Pacific Railroad, founded by Crocker, Stanford, Hopkins and Huntington at the hardware store at 54 K Street in 1861, was a Sacramento-based enterprise intended to challenge the San Francisco interests that had built the Sacramento Valley Railroad. Their secret weapon was SVRR's former engineer and longtime advocate of a Pacific railroad, Theodore Judah, who agreed to design their route over the Sierras and had surveyed a potential route the previous year. Groundbreaking for Central Pacific Railroad was held at the foot of K Street on January 8, 1863, and marked the beginning of the Pacific railroad's construction. Construction of the Union Pacific west from Omaha, Nebraska, did not begin until 1864.[35]

The rivalry between the Sacramento Valley Railroad and Sacramento intensified during the 1860s. SVRR's levee on R Street had made the 1861 flood worse by preventing drainage of floodwaters, and relations were still strained between the railroad and the city. During the era of street raising, some SVRR crews found city crews dumping fill dirt directly on their right of way, resulting in fistfights between men from the two companies. In 1862, the City of Sacramento increased SVRR's rates to transfer goods between its trains on Front Street and the riverboats, and in December 1862, passed an ordinance that required SVRR to remove its tracks on R Street west of Sixth Street, blocking direct access to the riverfront docks and its passenger depot on K Street—just one month before the groundbreaking ceremony for the new Central Pacific Railroad. SVRR responded by designing a new railroad route that ran from the Sacramento River several miles south of Sacramento to a new town, one it named Freeport to signify its lack of transfer charges. The combination of no transfer fees and a location several miles closer to San Francisco (and south of a notorious sandbar that sometimes cut off Sacramento river traffic during low tides) threatened Sacramento's traffic. Fortunately for Central Pacific, it was able to purchase SVRR in 1865, completing K Street's victory over R Street. The branch line to Freeport was removed, and SVRR became a branch line of Central Pacific.[36]

The competition between SVRR and Central Pacific was symbolic of the competition between Sacramento and San Francisco. San Francisco already had a larger population by 1860, about 60,000 people compared to 15,000 in Sacramento, and both cities were connected by transportation and economic ties. But Sacramento businessmen were already tired of being the junior partner. As the Sacramento Valley Railroad saw more business in the

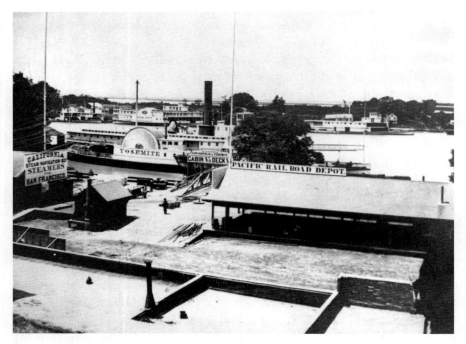

The foot of K Street, circa 1870, showing connection between riverboat and railroad lines. Sacramento's first streetcar lines also terminated here. *Center for Sacramento History.*

1850s during the Nevada silver rush, Sacramentans saw the flow of money from the Comstock Lode traveling down R Street and downriver to enrich San Francisco, with little money remaining in Sacramento. When Central Pacific was awarded the Pacific railroad contract, Sacramento alienated San Francisco and other California cities that had hoped to win the franchise, including Stockton, Placerville and Marysville, as well as companies based in those cities.[37]

Construction of the railroad took more than six years and was impeded by the Civil War. The war limited supplies of steel, gunpowder and men—all essential to warfare, as well as to railroad construction. The railroad obtained steel and gunpowder as it became available. For manpower, Charles Crocker tried an experimental force of fifty Chinese workers and found their work so satisfactory that by the time the railroad was completed, 12,000 Chinese workers were on the payroll. While the other principals of the Central Pacific eventually learned to appreciate the industry and skill of their Chinese workforce, the increased presence of the Chinese in

Raising K

California generated resentment from other California interests, especially when Chinese workers settled in California after the railroad's completion.

Completion of the Central Pacific on May 8, 1869, connected K Street to the rest of the nation. The depot at Front and K Streets became the end of the line until September 1869, when a branch to Oakland was completed. Many passengers en route to San Francisco transferred from the rough, primitive railroad cars to riverboats at K Street for the remainder of the trip. The riverboats were far more comfortable, and because they took a more direct route, the trip was shorter by riverboat than rail.[38]

For passengers disembarking in Sacramento—including those visiting the new state capitol building, still under construction in 1869, or the California State Fair, permanently located in Sacramento starting in 1860—the scene at the foot of K Street was a riot of people and vehicles. Hotel barkers urged travelers to stay at their hotel of choice. Passenger and freight locomotives shuttled back and forth through the passenger depot and the waterfront docks. Horse-drawn omnibuses and drayage wagons carried people and goods to and from the depot, and horse-drawn streetcars all came together at the foot of K Street.

July 4 on K Street: Independence Day Parades and "The Horribles"

In the era following the Civil War, Sacramento celebrated the Fourth of July with considerable reverence. After the long struggle, patriotism helped heal a wounded nation. In Sacramento, the Independence Day parade on K Street brought every local organization of note together, ending with a series of patriotic speeches, poems and a reading of the Declaration of Independence at the Grand Pavilion. In the shadow of this solemnity, a band of ill-tempered and intemperate Sacramentans held their own parade, meant to poke the pompous and temper the seriousness of the occasion with acts of public lunacy. They were called the Horribles.

Led by a General Sloverngovern, the group began in 1867 as the "Bummers," who marched dressed as women and Chinese workers, followed by an ersatz cannon made of old stovepipe that used pumpkins as ammunition. Positive responses encouraged them to return the following year, and eventually they became an official part of the parade, paid a subsidy by the city to sponsor them.

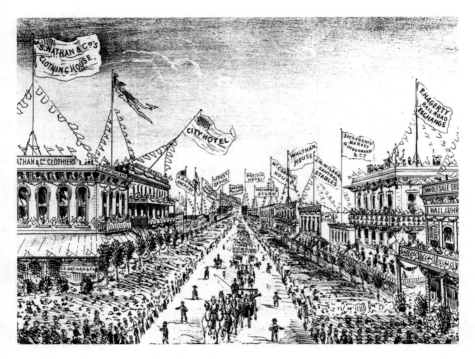

In addition to the Fourth of July, K Street was the most common parade route for any occasion. This drawing illustrates a grand procession for President Ulysses S. Grant, who visited on October 22, 1879. *Center for Sacramento History.*

Known as "the Fantastics" before later settling on the title of "the Horribles," the procession was led by their leader, sometimes called the "Jigadier Brindle" or "General Killemall," and his immense, bloody wooden sword. A threadbare Uncle Sam character often accompanied him, and both were mounted on the oldest, mangiest nags they could find. Entrants created floats that poked fun at local or national political figures or prominent businessmen. A "waffle wagon" deep-fried and sugared blocks of wood and then hurled them at the crowd. A float labeled "Daniel in the Lion's Den" featured a young man seated in a cage with several goats, dogs and cats. An acrobat, "Mademoiselle de Standononetoe," made futile attempts to do acrobatic stunts on horseback while a barker described the amazing feats that she obviously couldn't perform. A group of "genuine Indians" rode in a cart labeled "We Are the Native Sons of the Golden West," poking fun at a California organization of the same name that, at the time, was limited to the

Raising K

California-born sons of Europeans. Marching bands played instruments constructed of scrap wood or tin cans, mangling patriotic and popular songs of the day. Generally, the Horribles made as much noise as possible via fireworks, playing their improvised instruments or simply howling and shouting as loudly as they could.

At the end of the procession, a trio of "indignitaries"—the Declaimer, the Orator and the Poet—took the podium at the Grand Pavilion in a ceremony known as the "Illiterate Exercises." The Declaimer recited the annual "Declamation of Indignation," the Orator delivered a speech and the Poet read a poem. Each attempted to outdo the other with a stream of polysyllabic gibberish, the Poet doing so while trying to rhyme. The July 4, 1880 Orator's speech started thus:

> *Most benevolent malefactors, most potent, grave and reverend saloon keepers: It was but a few moments ago that it came to my notice that I should have the misfortune to inflict you with this ornate gush of oratory. This effusion of mine is as spontaneous as the essay is impromptu. I began work on this oration some three months ago, and I am glad to say I haven't got through with it yet.*[39]

In the summer of 1894, the massive Pullman Strike brought federal troops to Sacramento to dislodge strikers from the Southern Pacific Shops. Armies of strikers and soldiers faced off in a tense confrontation that eclipsed a small, subdued July Fourth parade, with no Horribles present. The strike represented a turning point in American history, foreshadowing an era of industrial progress, with less tolerance for public tomfoolery.

Some Sacramentans, including the editors of the *Sacramento Union*, publicly opposed the presence of the Horribles in the parade and considered them loutish, offensive and tasteless. Their occasional jabs against city hall, the board of trustees, the police force and civic leaders won them few friends in city government. The last Horribles parade was held in 1898, after their city subsidy ended. The Horribles may have been out of place in the more strait-laced era of the late Gilded Age or may have become an unwanted relic of Sacramento's rowdy frontier past. Or perhaps they simply made fun of the wrong politician.[40]

Sacramento's K Street

Mule-Drawn Streetcars on K Street

Sacramento's first streetcar company, a horse- or mule-drawn line from Front and K Streets to the SVRR Depot at Third and R Streets, was built in 1858 but lasted only three years, destroyed by the 1861 flood. Another streetcar line was impossible until the street-raising project of the 1860s was completed. The first permanent streetcar line, the City Street Railway, was established on August 20, 1870. Sacramento's original streetcars, pulled by mules, provided service from the Central Pacific Passenger Depot to the Union Park racetrack at Twentieth and H Streets. Streetcars made access to hotels, merchants, banks, the state capitol, the railroad depot and other downtown destinations convenient to city dwellers. The California State Fair's racetrack and Grand Pavilion were directly accessible by streetcar, a great convenience to out-of-town visitors. On their way, each state fair visitor passed the hotels, theaters, restaurants and department stores of K Street, a rolling advertisement for Sacramento's commercial district.

Aside from transporting state fair visitors, Sacramento's mule-drawn streetcars allowed the young city's middle class to live in comfortable residential neighborhoods and commute to work downtown. As the waterfront became louder, smokier and more crowded, the streetcar was a welcomed convenience. Neighborhoods located along the new streetcar lines quickly sprouted Italianate and Queen Anne houses where Sacramento's clerks, managers and artisans lived. Pleasure parks like East Park and Richmond Grove drew visitors to relax away from the heart of downtown. Streetcar mules were originally stabled at Tenth and K Streets, later moving farther east to Twentieth and K Streets.

Real estate developers used streetcars to draw customers to former farmland. Most routes had one end in a suburban neighborhood and the other end on K Street. In 1887, real estate developer Edwin K. Alsip, whose office was at 1015 K Street, purchased and subdivided a small ranch southeast of Sacramento and ran his Central Street Railway from downtown to his new development, creating the Oak Park suburb. The line also served the adjacent suburb of Highland Park, a name strategically chosen due to the site's location on high ground above flood level. Suburban neighborhoods were not viable without a downtown to provide jobs and a transportation system to move commuters back and forth.

Mule-powered cars were not without their problems; they were slow, put a cruel strain on the animals and emitted inevitable exhaust. Central

Raising K

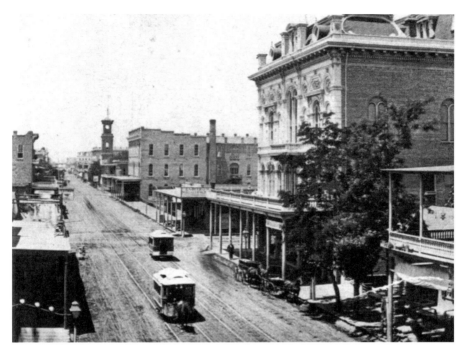

Mule-drawn streetcars at Eighth and K Streets on Sacramento's newly raised streets, circa 1870. *Author's collection.*

Street Railway briefly experimented with battery-powered electric streetcars in 1888 before switching to electric trolleys in 1890, powered by a coal-fired steam engine connected to an electric dynamo. The electric streetcar lessened the burdens of both the draft mule and the street sweeper.

Electricity in Sacramento and the Grand Electric Carnival

Sacramento's first commercial use of electric light came when the Weinstock & Lubin Mechanics' Store arranged a display of arc lights in front of their K Street store in conjunction with the 1879 state fair. Power was provided by a generator in the steam boiler room of the *Sacramento Record-Union* (the paper changed names several times over the years) and was transferred to Weinstock & Lubin via wires connected over the tops of buildings. On September 8, 1879, the arc lights activated before a crowd of about 5,000

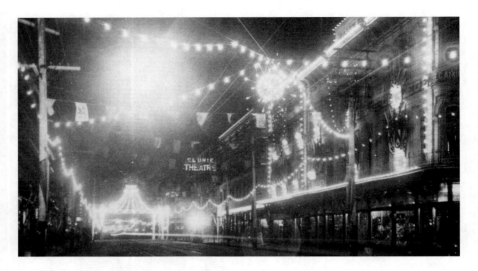

K Street between Eighth and Ninth, illuminated for the Electric Carnival. Photo taken September 9, 1895. *Center for Sacramento History.*

curiosity-seekers, making K Street's gas lamps (operating since December 1855) look feeble in comparison.

In 1895, a new hydroelectric generator twenty-two miles away in Folsom, California, was connected to Sacramento. This powerhouse was the joint project of industrialist H.P. Livermore and Albert Gallatin, former manager of the Huntington-Hopkins Hardware Store. The Folsom powerhouse provided enough electricity to power the streetcar system, with surplus to sell to industrial, commercial and residential customers in neighborhoods adjacent to the streetcar lines. By 1895, Sacramento's streetcar, power and gas companies had reorganized as the Sacramento Electric, Gas and Railway Company, a predecessor of Pacific Gas & Electric (PG&E). A grand celebration to commemorate the project's completion was scheduled for September 9, the day California was admitted to the Union. This event was named the Grand Electric Carnival.

The carnival featured a parade of illuminated floats, moved and lit by electric power on the electrified streetcar lines. Local organizations and businesses decorated elaborate floats, and K Street was festooned with strings of lights. Each of the twelve Southern Pacific Railroad Shop departments provided a float, the grounds around the Capitol Building were decorated with lights and an electric maypole was erected in Plaza Park. Southern Pacific offered a special rate for visitors from San Francisco,

and to ease the lack of available hotel rooms, the Native Sons of the Golden West compiled a list of rooms in private homes available for rent during the event.

The parade route began on Twenty-First and J Streets, went up Second Street, turned south on K Street and then back up toward Tenth Street, turned south again toward P Street and then went back up Fifteenth Street and ended at the Grand Pavilion of the state fair. The route ran entirely along the SEG&R's streetcar tracks, providing direct current to the electric-powered procession. Cavalry and marching units accompanied the electric vehicles. Floats included an American flag entirely composed of electric lights, a fruit and flower display, brass bands and every uniformed organization in the region, from National Guard companies to post office letter carriers. The dozen floats from the shops, all self-propelled and lit by the overhead wire, were the parade's grand finale, led by a brand-new electric freight locomotive. Thousands of Sacramentans and visitors from around the state witnessed the incandescent display, and newspaper reports marveled at the pageant and the technological miracles that made it possible.[41]

CHAPTER THREE

Progress and Prosperity

The lower quarter was not exclusively a Mexican barrio but a mix of many nationalities. Between L and N Streets two blocks from us, the Japanese had taken over. Their homes were in the alleys behind shops, which they advertised with signs covered with black scribbles…The Portuguese and Italian families gathered in their own neighborhoods along Fourth and Fifth Streets southward toward the Y Street levee. The Poles, Yugo-Slavs, and Koreans, too few to take over any particular part of it, were scattered throughout the barrio. Black men drifted in and out of town, working the waterfront. It was a kaleidoscope of colors and languages and customs that surprised and absorbed me at every turn."
—*Ernesto Galarza,* Barrio Boy

By the dawn of the twentieth century, Sacramento had turned its location into its main advantage. At the center of an enormous agricultural region, and with multiple transportation routes, the city became the processing center for agricultural and natural resources for the entire valley. Sacramento's earliest generation of businessmen, including Sam Brannan and the Central Pacific's Big Four, had moved from Sacramento to San Francisco, taking their fortunes with them. While San Francisco's wealth came from gold and silver mining in the Sierra Nevada, Sacramento's wealth came from its surrounding farm regions, converting agricultural products into transportable commodities. Sacramento's first millionaires took their fortunes and moved to San Francisco, but a second generation of businessmen emerged to take the earlier businessmen's place on K Street. Often, these businessmen also had economic interests in regional agriculture.

Progress and Prosperity

California agriculture followed a different model than the family farm found across much of the United States. Sacramento and San Joaquin Valley farms were much larger, investor-owned operations. Instead of tenant farmers who lived on the land, most of the work was performed by migrant laborers, who worked intensely during planting and harvest seasons but were not employed by the farm during the rest of the year. Historian Carey McWilliams called them "Factories in the Field," the agricultural equivalent of the nineteenth-century factories of the Industrial Revolution. Many Sacramento Valley farm owners were businessmen who lived in Sacramento. The migrant laborers who worked their farms also lived in Sacramento in between planting and harvest seasons, in hotels and boardinghouses near the waterfront and in the immigrant neighborhoods along the western end of K Street. These workers shared quarters with the thousands who worked in waterfront industries, the Southern Pacific Shops and yards, the city docks and the multitude of canneries, mills, lumberyards and other industries along the Front Street levee.

In *The California Progressives*, historian George Mowry identified the Progressives of the early twentieth century as a middle-class phenomenon, primarily consisting of conservative Republicans. In 1893, the World's Columbian Exposition in Chicago prompted American cities to rethink their architecture and city planning. An economic panic in 1893 spurred a wave of labor unrest across the country, including the great Pullman Strike in 1894. The Populist movement united rural farmers in the 1870s and 1880s, an era of economic instability and alternating market bubbles and panics. The Progressive movement of the 1890s followed the Populist movement, but it emerged from the urban middle class, calling for greater economic stability after the wild market fluctuations of the late twentieth century, as well as an end to business monopolies that raised prices and restricted competition. In Sacramento, many middle-class businessmen, including farm owners, became part of the Progressive movement. As the seat of state government, Sacramento became an important part of the Progressive era's national legacy. Progressives saw monopolistic companies like Southern Pacific and Pacific Gas & Electric (PG&E) as threats to their own business interests due to their control over transportation and power rates. While the "Big Four" of Central Pacific (known as Southern Pacific by the 1890s) started out in Sacramento and battled San Francisco's dominance, all had left Sacramento for residences in San Francisco by the mid-1870s, as did Sacramento hardware merchant Albert Gallatin before founding PG&E. Sacramento's remaining businessmen considered this a betrayal but, due to

their enormous role in the Sacramento economy, could not avoid doing business with them.⁴²

Sacramento native Hiram Johnson was the leading figure of California progressivism in the early twentieth century. Born in 1866, Johnson was the son of attorney Grove Johnson, a member of the United States Congress in the 1890s and later the California legislature. Hiram grew up in Sacramento and after college joined his father's law practice. He and his brother Albert worked on his father's congressional campaign, but refused to endorse his reelection due to his support of the Southern Pacific Railroad, a schism that estranged Grove from his sons for many years. Hiram was appointed city attorney by Sacramento mayor George Clark in 1900 and began a crusade against gambling and other forms of vice in Sacramento's pool halls and saloons. After helping reelect George Clark, Johnson moved to San Francisco, where his reputation as a crusader against corruption was made by prosecuting San Francisco mayor Eugene Schmitz and political boss Abraham Ruef in the wake of the 1906 earthquake and fire. He supported the Lincoln-Roosevelt League, an alliance of progressive Republicans, and was elected governor of California in 1910 as an anti-corruption crusader intent on limiting Southern Pacific's power in California. With a native son in the Governor's Mansion, Sacramento Progressives had much reason for optimism.⁴³

Sacramento native and California governor Hiram Johnson giving a speech in Sacramento. *Center for Sacramento History.*

THE SACRAMENTO CHAMBER OF COMMERCE AND THE RESTORATION OF SUTTER'S FORT

In September 1895, Sacramento's business community formed the Sacramento Chamber of Commerce to foster business in the Sacramento

Progress and Prosperity

region and encourage growth in the city. Its first office was on J Street, but most of the merchants who joined the chamber of commerce had commercial locations on K Street. They often used K Street as the site for parades, pageants and celebrations. The 1895 Grand Electric Carnival and the electric power it celebrated marked the beginning of a new era on K Street. It was a useful marketing tool and became the model for later festivals, but the real boon that the carnival celebrated was the advent of cheap, abundant and sustainable electric power.

During this era, K Street was the only place in the city with large department stores between Oakland and Reno, so it was a regional destination. Local streetcars and interurban trains shared the street with pedestrians, bicycles, horse-drawn carriages, wagons and even some automobiles. Between the department stores and specialty retail shops were theaters featuring vaudeville acts, dance halls and the new moving-picture theaters. Restaurants and bars in the business district satisfied Sacramentans' hunger and thirst. K Street also featured hotels catering to travelers and visitors and apartments for downtown residents. Sacramento's business district also had its underside in the form of gambling parlors, pool halls, taverns and brothels closer to the waterfront. Progressive members of the chamber of commerce criticized city government as too tolerant of vice and accused Southern Pacific and PG&E of undue influence at city hall.

On the eastern edge of K Street, Sutter's Fort had seriously decayed, leaving only a central building by 1895. William Warner's 1849 street plan ran L Street through the fort's walls, and when growth on L Street pushed close enough to threaten the fort, local fraternal organizations (including the Society of California Pioneers and Native Sons of the Golden West) and the chamber of commerce intervened to protect the fort. They petitioned the city to curve L Street around the fort's perimeter, raised funds to rebuild the fort's walls and donated the reconstructed fort to the State of California for conversion to a museum and park.

The fort represented more than just a historic site to Sacramento's Progressives. Up to the 1890s, Sutter was almost as forgotten as his fort, but like his fort's reconstruction, his image as a historical figure was polished to meet a contemporary need. Instead of the semi-competent trader outwitted by merchants and overrun by miners, Sutter was portrayed as a visionary, whose dream of an agriculture-centered New Helvetia was crushed by greedy city builders and their hordes of immigrants, his pastoral farmlands polluted by mining and industry. This image of Sutter bore little similarity to

Sacramento's K Street

This 1916 parade float on K Street demonstrated the solidarity of Sacramento's Italian immigrants with their countrymen involved in World War I, even before the United States was officially involved in the conflict. The same parade also featured a similar float representing Portuguese soldiers. *Center for Sacramento History.*

Threatened by demolition in the 1890s, Sutter's Fort became a symbol of the Progressive agrarian vision for Sacramento. Groups like the Native Sons of the Golden West and the Society of California Pioneers spearheaded efforts to rebuild the fort. The St. Francis Cathedral, constructed in 1910, sits behind the fort. *Center for Sacramento History.*

Progress and Prosperity

Sutter the historic figure, but the resemblance to Sacramento's agricultural entrepreneurs was unmistakable.[44]

In June 1899, buoyed by the success of the Electric Carnival, a subcommittee of the chamber of commerce started plans for a new annual event. Established as the State Fair Club, its objective was to make better use of the state fair facilities, the racetrack at Twentieth and H Streets and the pavilion at Fifteenth and M Streets. The first Sacramento Street Fair and Trades Carnival, planned for April 30, was a weeklong celebration that used the state fair facilities, but much of the street fair took place on K Street and on adjacent business streets. Floral parades led by the Capital City Wheelmen, maypole dances, military marches and a three-hundred-foot long Chinese dragon march filled the streets of the business district, and chamber of commerce members hoped this event would fill hotel rooms and restaurants to capacity.[45]

By 1903, the Street Fair and Trades Carnival had grown to the point where state senator Grove Johnson (Hiram Johnson's father) remarked, "You've ruined the state fair by running your grand, magnificent and glorious street fairs!" After 1905, the state fair moved to new quarters on Stockton and Broadway, leaving the chamber of commerce without a downtown facility to host the fair.[46]

LIFE ON K STREET: HOTELS AND APARTMENTS, VAUDEVILLE AND MOVIE THEATERS

From the days of the gold rush, Sacramento businessmen like the Crocker brothers or Yee Fung Chung started out living in modest quarters above their stores in the downtown business district. Subsequent generations of small business owners followed the same patterns into the twentieth century. In Sacramento's early days, when the business district only reached a few blocks inland, K Street still featured single-family residences, often interspersed with businesses. As the business district expanded, single-family homes along K Street were replaced by more intensive uses, both commercial and residential.

Some of Sacramento's first buildings were hotels, intended for miners on their way to the mother lode or spending the winter in Sacramento before returning to their claim. The first purpose-built hotel was the City Hotel at 919 Front Street, constructed in 1849 using timbers originally intended for John Sutter's flour mill near Brighton. By 1851, fifty-four

Sacramento's K Street

In the foreground are the Golden Eagle Hotel and the city horse market, circa 1868. Behind the hotel is St. Rose of Lima Church at Seventh and K Streets, Sacramento's first Catholic church built on land donated by Peter Burnett in 1850. This version of the church was built in 1861, replacing an earlier wooden building. *Center for Sacramento History.*

hotels and forty boardinghouses were listed in the city directory. By the 1890s, a newer generation of elaborately designed hotels in popular architectural styles lined K Street and were just a short streetcar ride from Central Pacific's new Gothic Revival arcade depot at Second and H Streets, which replaced its original passenger depot at Front and K Streets in 1879. Many of the gold rush–era hotels not destroyed by subsequent floods and fires were demoted in status to inexpensive railroad hotels as the end of K Street nearest the waterfront took on a far more industrial character.

Most of these hotels, both elegant and plain, were occupied by travelers or temporary sojourners, but many had long-term occupants. Waterfront hotels provided inexpensive winter quarters for migrant laborers. State senators, assemblymen and administrative aides lived in comfortable hotels just a few blocks from the capitol for months during the legislative season, returning home when the legislature adjourned. Others had estates or farms in the Sacramento Valley but needed a convenient place to stay while doing

business in Sacramento. Professionals, business owners and elected officials called for a higher level of service than migrant farm workers, and the hotels where they lived reflected the status of their occupants.

Some K Street hotels, like the Golden Eagle, were reinvented by their owners to better serve the customers of the post–gold rush era. The original Golden Eagle Hotel was constructed in late 1850 by Daniel Callahan on two parcels near Seventh and K Streets, where a canvas structure first called Callahan's Place stood. In 1851, Callahan built a wooden-frame building in the canvas structure's place, but it did not survive the fire of 1852, so it was temporarily replaced with another canvas tent. In 1853, he mortgaged the property and bought another adjacent lot to build a new brick hotel, the Golden Eagle, with a granite front façade. This building was so fireproof it was credited with stopping the second great Sacramento fire in 1854. Due to the proximity of Sacramento's horse market across K Street, the new Golden Eagle became a preferred residence of ranchers visiting Sacramento to trade livestock As the business district expanded, nearby property owners lodged complaints about the smell from the horse market and the occasional policy of "test-driving" animals down the city's thoroughfares at breakneck speeds. The ground floor of the Golden Eagle featured a restaurant called the Golden Eagle Oyster Saloon.

The building was elevated to the new grade and extended to the corner of Seventh and K Streets in 1867. By 1869, Callahan had completed a new Italianate façade that gave the Golden Eagle a stately grandeur. By 1870, Callahan's neighbors included John Breuner's furniture store, across K Street, and the St. Rose of Lima Church, Sacramento's first Catholic church, just across Seventh Street. However, Callahan encountered financial difficulty and lost the Golden Eagle to his creditors, including John Breuner, in August 1874. According to Sacramento's 1889 Blue Book social register, the Golden Eagle Hotel at 617 K Street was the home of People's Savings Bank president William Beckman and also Warren O. Bowers, the new owner of the Golden Eagle.

By 1902, the Golden Eagle was still home to some of Sacramento's notables, but owner Warren O. Bowers had relocated to the Capital Hotel across K Street, a newer hotel with bay windows and fashionable Queen Anne architecture that replaced the odious horse market. Bowers came to Sacramento in 1867, working for the Central Pacific Railroad until 1878, when he purchased the Union Hotel on Second and K Streets. Other preferred hotels listed in Sacramento's 1902 Blue Book include the State House Hotel and the Western Hotel, both at Tenth and K. Hotels like the

Clunie, Coloma, Regis, Turclu, Berry, Californian, Ramona, Shasta and Argus provided rest for sojourners and more permanent homes for downtown residents. Many of these hotels were designed by prominent local architects, like the Hotel Sacramento at Tenth and K Streets, designed by former state architect George Sellon and built for Albert Bettens in 1910.[47]

While Sacramento's hotels may not have met the standards of the finest palace hotels of New York and San Francisco, they were comfortable enough for many of Sacramento's political class and business elite or those aspiring to that position. In 1919, young attorney Earl Warren lived in the Sequoia Hotel at 911 K Street, constructed in 1911, when he was a staff attorney for the California State Assembly Judiciary Committee. He later adopted more spacious quarters as governor or California.

In the early twentieth century, a new type of residential building appeared on K Street. Modern apartment buildings provided the proximity to job centers of older hotels but were intended for permanent residency. Instead of shared bathrooms, apartments had their own plumbing and often had kitchens, lessening apartment dwellers' dependence on local restaurants or hotel room service. Apartment buildings like the Merrium, Maydestone, Francesca and Howe Apartments were generally not found directly on K Street, where businesses and hotels predominated. They were located on adjacent numbered streets within a block of K Street, providing convenient access to multiple downtown job centers.

The American Cash Apartments at 1117 Eighth Street, constructed in 1909, is a prime example of this sort of downtown apartment building. Designed by George Sellon in the Craftsman style, the ground floor housed the American Cash Store, a grocery store and the James Hays meat market, with twenty-four apartments composing its upper stories. Later commercial tenants included the J.Q. Fochetti Bakery, hat cleaner Wadyslaw Salmonki, the Muzio French-Italian Bakery, Otto Allen Liquors and the Fort Sutter Stamp Company. In 1938, the building was home to six laborers, two department store managers, three clerks, two railroad workers, a doctor, a nurse, a state commissioner and eight bartenders. By 1940, the building was renamed Bel-Vue Apartments.[48]

In 1895, K Street had three theaters: the Comique at 117 K, the Metropolitan between Fourth and Fifth Streets and the Clunie Theatre, attached to the Clunie Hotel, between Eighth and Ninth; the latter two were managed by J.H. Todd. Touring theater companies provided Sacramento with a variety of burlesque, vaudeville and traditional theatrical entertainment. One of the earliest movie theaters was Grauman's at Sixth

Progress and Prosperity

The Hotel Sacramento and Hotel Land both sat on K Street, on opposite sides of Tenth Street. Both were built in 1910. They were primarily intended for travelers, but some of Sacramento's most prominent citizens lived in downtown hotels, part time or full time. Across from the Hotel Sacramento was the Hippodrome, a vaudeville house and movie theater first constructed as the Empress Theatre. *Center for Sacramento History.*

and J, where George Melies's *From the Earth to the Moon* was shown in 1903, in addition to a vaudeville program. In the first decade of the twentieth century, many former vaudeville theaters showed early movies, and a handful of movie theaters converted existing buildings into movie houses. The Unique, opened in 1903, may have been the first opened as a movie theater rather than a vaudeville stage, but it later added live acts before relocating to 613 K Street in 1905. The same address operated as a theater under many names, including the Alisky in 1906, the Pantages in 1908, the Garrick in 1914, the T&D in 1917 and the Capitol in 1923, which it remained until 1957. Many Sacramento theaters operated under different names over the years, sometimes remodeling the building but often changing little more than the name on the sign.

Charles W. Godard operated multiple theaters on or near K Street, including the Liberty Theater at 617, the Majestic at 310 and the Acme

at 1115 Seventh Street. His theaters focused on luxury and comfort, with modern heating and cooling systems, wicker loge seats and even a Japanese tearoom. The Empress opened at 1013 K Street on January 19, 1903, a two-thousand-seat vaudeville theater costing $150,000. The Empress featured a children's nursery, smoking room, telephone booths and a modern ventilating system. But vaudeville was losing popularity to movies. In 1918, the Empress began showing films, and owner Marcus Loew changed its name to Loew's Hippodrome, often called simply "the Hip." A fire in August 1918 damaged the theater, ending vaudeville performances after fire repairs were complete, and a second fire in 1921 caused more damage.[49]

The Progress and Prosperity Committee

By 1910, Sacramento's gold rush era was long past, its role as western terminus of the Transcontinental Railroad superseded by Oakland and its place as the second largest California city long since lost to Los Angeles. Despite these setbacks, the chamber of commerce felt that Sacramento was poised for greatness and created a Progress and Prosperity Committee to focus on future plans for the city.

In 1909, a state referendum attempted to move the state capitol from Sacramento to Berkeley. The measure was defeated, but in response the Progress and Prosperity Committee sought recommendations for civic improvement by three of the most highly respected urban planners of the early twentieth century: Charles Mulford Robinson, Werner Hegemann and John Nolen. Between 1909 and 1915, after brief visits to Sacramento, each prepared a report recommending various changes.[50]

Charles Mulford Robinson's report advised clearing the railroads from the waterfront and moving the industrial district north of the Southern Pacific Shops in order to allow beautification of the waterfront and creation of diagonal boulevards to allow direct access from Oak Park and other suburbs to the state capitol. He also recommended wholesale relocation of the American River, shifting its main channel south of Sacramento to allow unimpeded suburban expansion northward, beyond a new industrial zone north of the Southern Pacific Shops. Werner Hegemann recommended turning M Street into a grand boulevard and described K Street as "meaningless and vile."

Park architect John Nolen's plan included grand recommendations for a new Del Paso Park but was critical of high-density growth in downtown

Progress and Prosperity

Sacramento, and in a November 1915 report to the chamber of commerce, he described the new generation of skyscrapers (the Forum Building on K Street and the Fruit Exchange on J Street, for example) as "an unqualified evil." Sacramento's business community was still centered on K Street, with the city's entire population a one-mile walk or a short streetcar ride away. According to all three of the most eminent urban planners of the era, the future of Sacramento was in the suburbs to the north and east of the city limits.[51]

Sacramento's new city hall building, completed in 1911, was first occupied by Mayor Marshall Beard, the last "strong mayor" of Sacramento. The 1893 strong mayor charter replaced the earlier 1863 charter's three at-large trustees with a full-time executive mayor and a legislative board of trustees. This system was promoted by Sacramento's business community and many founders of the chamber of commerce, who felt that more mayoral power would encourage businesslike efficiency and economy. Among the fifteen persons on the board of trustees elected in 1891 to rewrite the city charter were lawyer-industrialist and real estate developer Clinton L. White and department store magnate Harris Weinstock. Beard was a prominent member of Sacramento's Democratic Party and a member of the chamber of commerce, and he held multiple elected positions, sitting on the city's board of trustees and acting as superintendent of schools before being elected mayor in 1905 and again in 1911.

Beard was sometimes called "Boss Beard," but many assumed the real power at city hall was held by board of trustees president E.P. Hammond and E.J. Carraghar, chair of the finance committee. Under this system, many residents felt that the city's best interests took a backseat to big business interests. The strongest of those interests were Pacific Gas & Electric and the Southern Pacific Railroad.

Since its absorption of competing California railroads in the 1860s, Southern Pacific held an interstate transportation monopoly in northern California and had an enormous influence on state and local politics. The Southern Pacific Shops and Locomotive Works produced everything from hand tools to full-sized steam locomotives and was the main repair and supply facility for Southern Pacific's national system. However, when Stanford, Crocker, Hunting and Hopkins moved from Sacramento to San Francisco, they took the railroad's business offices with them. The company that formed to put Sacramento on an equal footing with San Francisco had left town. Reformers in Sacramento and throughout the state felt the railroad had too much influence on city politics, and its monopoly on transportation held Sacramento back while San Francisco reaped the benefits.[52]

SACRAMENTO'S K STREET

ELECTRIC INTERURBANS LINK K STREET TO THE VALLEY

A phenomenon of the late nineteenth and early twentieth centuries, interurban railroads served distances too long for a streetcar but too short for a steam railroad. Their passenger vehicles were also somewhere in between the two in size, powered by overhead electric wires or third rail and operable in multicar trains. Sacramento's first interurban was Northern Electric, a route from Chico that reached Sacramento in 1907. Northern Electric's Sacramento Depot was located at the corner of Eighth and J Streets, allowing shoppers from nearby cities and farm towns direct access to K Street, one block away. Northern Electric also operated freight trains, but it was forbidden from downtown Sacramento streets. Northern Electric operated local streetcars between K Street and McKinley Park on Alhambra Boulevard via C Street. Like the local PG&E streetcars, Northern Electric trains were powered by PG&E's hydroelectric and oil-fired generators.

In 1911, Northern Electric built a railroad bridge across the Sacramento River at M Street as part of its expansion to the nearby city of Woodland and, in conjunction with the West Sacramento Land Company, started suburban streetcar service to its new suburb in 1913. This western branch was intended to become a new electric railroad to the Bay Area, the Vallejo & Northern, but was never completed. Another branch was added in 1913 to serve the new community of North Sacramento. Originally proposed to reach all the way to Orangevale, it, like the Vallejo & Northern, was never completed, and its route ended at the Swanston meatpacking plant. South of the M Street Bridge sat the river lines' steam-powered riverboats, *Capital City* and *Navajo*, which made nightly runs from Sacramento to San Francisco. This new embarkation point at M Street moved riverboat traffic from its location at the foot of K Street.

Northern Electric abandoned its plans to build a route to the Bay Area when a competing electric railroad from Oakland, the Oakland & Antioch, arrived from the southeast, using the new M Street bridge (via a lease agreement with Northern Electric) to bring Bay Area and Sacramento Delta passengers to Sacramento. Its passenger depot crossed K Street at Third before stopping at the passenger depot at Second and I Streets, just south of the Southern Pacific Depot. The O&A later renamed itself the Oakland Antioch & Eastern but never built tracks to Antioch.[53]

From the south, another interurban, Central California Traction (CCT), which operated from Sacramento to Stockton, arrived in 1909. CCT's

Progress and Prosperity

The intersection of Eighth and K Streets was the hub of electric transit in the Sacramento Valley. On the left is a PG&E streetcar on K Street. On the right is a Central California Traction local streetcar and a Sacramento Northern interurban coach. From this corner, a traveler could reach Chico, Woodland, Oakland, Stockton or anywhere in Sacramento. *Center for Sacramento History.*

route ran through Oak Park via Stockton Boulevard past the new California State Fairgrounds, shared Northern Electric's freight route on X Street and terminated at its own depot at 1024 Eighth Street, half a block south of the Northern Electric Depot and just north of K Street. Like Northern Electric, Central California Traction also carried freight and operated a local streetcar between Eighth and K and the new suburbs of Colonial Heights and Colonial Acres, developed by affiliates of the interurban company. Electric power for CCT and its new suburbs was provided by the Great Western Power Company, a PG&E competitor.

Three interurban railroads with separate facilities may have caused confusion for passengers, but in 1925, a union depot was built south of H Street between Eleventh and Twelfth Streets, facing an alley renamed Terminal Way. By 1926, all three interurbans stopped at the new Union Station, and in 1929, the lines that started as Northern Electric and Oakland & Antioch became a single railroad, the Sacramento Northern Railway.

However, due to its importance as a shopping and business destination, Sacramento Northern and Central California Traction streetcars still met at Eighth and K Streets, and interurban trains stopped there on their way to or from Oakland and Stockton.[54]

Western Pacific: The Last Transcontinental Railroad Reaches K Street

Western Pacific, the last of America's transcontinental railroads, was the western link of three roads all owned by financier George Jay Gould. Combined with the Denver & Rio Grande Western from Salt Lake City to Denver and the Chicago, Burlington & Quincy from Denver to Chicago, it competed directly with the giant Southern Pacific, breaking Southern Pacific's monopoly on northern California railroad traffic. Western Pacific ran from Salt Lake City to Oakland, California, and passed directly through Sacramento. Prior to Western Pacific's arrival, nearly every product shipped to or sent from Sacramento, and nearly every passenger entering or leaving Northern California, traveled on Southern Pacific trains, barges or riverboats.

Running a new steam railroad through Sacramento was not a simple proposition. Electric railroads, like the streetcar and interurban companies, obtained franchises to run on city streets from the board of trustees, but steam railroads were required to gain the written consent of two-thirds of the property owners adjoining the railroad. Realizing that this task was nearly impossible, primarily due to Southern Pacific's interest in maintaining its monopoly, Western Pacific chief engineer V.C. Bogue planned a different approach outlined in a letter to the *Sacramento Bee* on October 7, 1907. Instead of running on a city street, Western Pacific purchased an eighty-foot right of way from property owners between Nineteenth and Twentieth Streets. Edward James Carraghar, the president of the Sacramento Board of Trustees in 1907, objected to the route because "it would practically destroy the very best residence district of our fair city."[55] Carraghar, owner of the Saddle Rock Tavern at Second and K Streets, was closely allied with Southern Pacific and the interests of the city waterfront.

This initial resistance to Western Pacific's arrival prompted several proposals to mitigate the effects of steam locomotives running through a mostly residential district. Some advocated for an elevated railroad route to prevent trains from blocking streets, but others felt elevated railroad

Progress and Prosperity

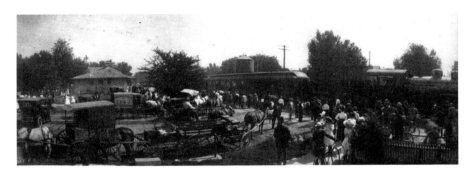

Western Pacific's first passenger train operated on August 21, 1910. It gave Sacramento its second transcontinental railroad, bringing railroad competition and new jobs but not a real estate boom. *Author's collection.*

structures were an even greater hazard to the city. Western Pacific proposed landscaping its right of way into a parkway and building overhead crossings on the busiest pedestrian streets. While Western Pacific's entry was opposed by the board of trustees, it had the full support of the chamber of commerce, which welcomed the railroad as a way to break Southern Pacific's monopoly. The trustees voted against granting the franchise, so the chamber backed a public referendum to decide the issue. On October 22, 1907, Sacramento's voters approved Western Pacific's plan, and the way through Sacramento was ensured. Former chamber of commerce president Clinton L. White, a Progressive reformer, real estate developer and public opponent of the Southern Pacific, was elected mayor of Sacramento in the same election.

Sacramento was a critical location for Western Pacific, due to its already-established role as the collection point and processing center for agricultural goods and natural resources in the Sacramento Valley. As the only major city between Salt Lake City and Oakland, Sacramento also had a large, skilled workforce and could supply the workers needed for Western Pacific's planned main railroad shop. A subcommittee of the chamber of commerce, including Valentine S. McClatchy of the *Sacramento Bee*, William Schaw of Schaw Bros. Manufacturing, George W. Peltier of the California State Bank and real estate developer P.C. Drescher, bought properties south of Sacramento and gave the land to Western Pacific in January 1909 for use as a railroad shop.[56]

Sacramento's Western Pacific passenger depot, located next to the new mainline between J and K Streets, was designed by Willis Polk, an architect of the D.H. Burnham Company of Chicago. It was considered one of Sacramento's finest examples of the Mission Revival style, with deeply

In 1908, Sacramento High School moved from its original location on M Street to Eighteenth and K Streets, closer to the Progressive middle-class neighborhoods and farther from downtown. It later became John Sutter Junior High School. *Center for Sacramento History.*

recessed quatrefoils in the gable ends, a clay tile roof and broad arcades to shelter passengers from both rain and sun. Its sprawling design stretched between Sacramento's two main business streets and was accessible via streetcar lines on either end. For residents of the eastern half of Sacramento, including Sacramento's growing middle class, the Western Pacific Depot was far more convenient than the Southern Pacific Depot downtown.

The building was completed in 1909, the same year that the Western Pacific began freight service, but passenger service had to wait until other facilities were completed. Western Pacific also constructed its main repair shop in Sacramento, hiring many Sacramento workers trained in the Southern Pacific Shops. The first day of passenger operation, August 21, 1910, came with considerable fanfare. The official timetable establishing passenger service was not adopted until the following day, with the first official train leaving Oakland for Salt Lake City on August 22.[57]

The arrival of the Atchison, Topeka & Santa Fe Railroad in Los Angeles in 1884 spurred an enormous Southern California real estate boom, and AT&SF's arrival in San Francisco via the San Francisco & San Joaquin Valley Railroad in 1896 promoted similar growth in the Bay Area. The chamber of commerce was eager to see the same sort of growth in Sacramento. The era of political reform and anti-monopoly sentiment and

the strong support of the chamber of commerce encouraged the city to accept this new competitor despite Southern Pacific's influence.

However, Progressive regulatory reform already passed at the national level also limited the railroad rate wars. AT&SF's arrival in Southern California caused an enormous housing bubble in the 1880s that turned Los Angeles from a quiet ranching town into California's second biggest city. Sacramento grew because of the Western Pacific, but not to the dramatic extent seen in Los Angeles or the Bay Area, although it was also spared the devastating housing market crash that followed the bubble. Still, the beginning of Western Pacific service in 1909 and the opening of the Western Pacific Depot in August 1910 were as welcomed as the jobs at the Western Pacific Shops. The Jeffery Shops became Western Pacific's primary maintenance facility, and their presence also gave Sacramento the unique distinction of being the only city in the United States containing two transcontinental railroads' main shops.

The Legacies of David Lubin and Harris Weinstock

David Lubin was born in Poland on June 1, 1849. His family immigrated to New York City, where he grew up on the Lower East Side. Trained as a jewelry maker, he worked as a craftsman, gold prospector, traveling salesman and even as a cowboy. He arrived in Sacramento in October 1874, renting a small space at Fourth and K Streets where he opened a dry goods store. Three years later, he partnered with his half brother Harris Weinstock and expanded his Mechanic's Store. In order to meet the Central Pacific Railroad Shops workers' demands for durable work clothes, Lubin designed his own line of heavy-duty overalls manufactured in his store on K Street. By 1891, the Weinstock, Lubin & Company store marketed itself as the largest general retail establishment on the West Coast.

In the same year, they opened a grand four-story department store at Fourth and K Streets atop their original 120-square-foot retail space. The building was designed to resemble the A.T. Stewart Company Department Store on Broadway in New York City. The interior was a gigantic sales floor with an enormous light well and three levels of sales galleries around the building perimeter. A basement level even utilized the spaces under K Street's sidewalks as part of the sales floor. Just as Sacramento's first generation of entrepreneurs like Stanford and Crocker moved from Sacramento to San Francisco, men like Lubin and Weinstock took their place, building their

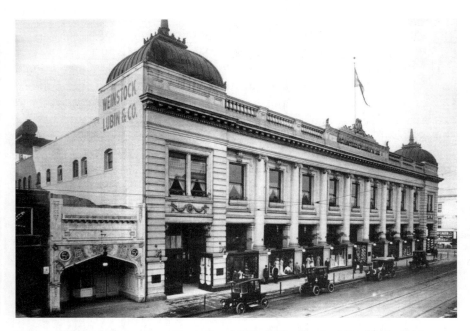

Weinstock & Lubin Department Store, circa 1912, rebuilt after the 1904 fire. In 1924, a new location was built at Twelfth and K Streets, replacing this store. To the left of the department store is the Edison Theatre, one of Sacramento's earliest movie theaters. *Center for Sacramento History.*

homes along the H Street streetcar line through Alkali Flat, north of K Street and farther from the waterfront. Their neighbors included fellow K Street department store owner Edward W. Hale, new president of the Huntington-Hopkins Hardware empire Albert Gallatin and agricultural investor R.S. Carey.

Lubin's legacy went beyond his business empire. After an 1884 trip to Jerusalem, he experienced a crisis of conscience and sought ways to look beyond the needs of his business for personal fulfillment. In Sacramento, he helped form the California Museum Association and urged Margaret Crocker, the widow of Edwin Bryant Crocker (who had died in 1875), to leave her family's art collection and its art gallery to the City of Sacramento to be maintained as a public museum. Margaret took his advice, donating the museum and its collection to the City of Sacramento in 1885. Weinstock and Lubin also helped establish the Crocker School of Design, and Lubin was instrumental in creating a state Indian Museum alongside the reconstructed Sutter Fort. While the Indian Museum was small, it became Sacramento's

first public institution dedicated to the people who had inhabited the land for millennia before Europeans arrived.

Lubin was also concerned with issues of world hunger and agricultural distribution. He established an experimental ranch north of Sacramento in Colusa County, researching methods of agricultural production. His research quickly proved that California's potential for agriculture far outweighed the riches of its gold mines but limited means of distribution and that freight rates, as set by the Southern Pacific Railroad, meant the farmers of California saw minimal benefit from the value of their crops. The necessity of wholesale distribution limited the power of small farmers, giving the advantage to large landowners who could fill entire trains with goods. Lubin sought ways to connect the farmer directly with the consumer and eliminate the middlemen of distribution where possible.

Lubin's experiments in the Sacramento Valley eventually led him to Rome, where he started an international organization to address the issues of world hunger and ways to modernize agronomy and worldwide food distribution. The International Institute of Agriculture lives on today as the Food and Agriculture Organization of the United Nations and is still headquartered in Rome.[58]

The Weinstock & Lubin Department Store expanded twice, adding annexes in 1900 and increasing the store's frontage on K Street by forty feet in 1901. In 1898, the company opened a store in San Francisco. On January 31, 1903, the Sacramento store was destroyed by fire, and nine days later, the store opened temporary quarters at the former Agriculture Hall of the California State Fair located at Sixth and M Streets. A new store was completed on Fourth and K Streets in 1904, less than a year after the fire.[59]

David's son Simon Lubin took over the Sacramento Weinstock & Lubin store until 1932 and followed his father's example by entering into the world of social reform. In 1912, he was appointed president of California's first Commission of Immigration and Housing by Governor Hiram Johnson.[60]

Harris Weinstock was born in London, England, in 1854. His family immigrated to the United States a year later, and he relocated to San Francisco in 1869. While David Lubin studied agriculture, Weinstock concerned himself with labor. Weinstock had experienced labor struggle directly while he was an officer in the California National Guard assigned to break the 1894 Pullman Strike at the Sacramento shops. The Weinstock & Lubin Department Store was well-known for its excellent labor relations and unionized labor force. In 1910, Weinstock was assigned by California

governor James Gillett to prepare a report on the labor laws and conditions of Europe to see what California could learn in addressing labor problems. Weinstock traveled extensively in Europe with Lubin on behalf of the American Commission and was appointed to the Industrial Relations Commission by President Woodrow Wilson and Secretary of State William Jennings Bryan.[61] In his 1910 report, Weinstock stated:

> *The idea of the worker being entitled to a voice in the matter of wages, hours of labor, or conditions of employment, seemed to the employer an impossible thought, and for the worker even to hint at such a right on his part was regarded as a bit of arrogance and a decided impertinence meriting instant dismissal. Conditions, however, have changed. Labor unionism has done much to educate the employer to the fact that the worker is entitled to a voice in all things affecting his own welfare. Trade unionism has through hard fought battles involving at times great industrial wars, with their frightful consequent sufferings to both sides and to society generally, forced upon even the most aristocratic and arrogant among employers the fact that it is a power to be reckoned with.*[62]

Weinstock was even considered as a candidate for governor of California in 1910 by the Lincoln-Roosevelt League, an organization of progressive Republicans, but Weinstock, a supporter of Sacramento-born attorney Hiram Johnson's gubernatorial campaign, refused to run.[63]

Progressive Philanthropists: William Land and Sarah Clayton

Born in rural New York in 1837, William Land came to Sacramento in 1860, securing a job as a busboy at the Western Hotel on Second and K Streets. He married a housekeeper at the hotel, Katie Donnelly, but she died in 1870, followed less than a month later by their son Willie. By 1871, he had saved enough to buy the hotel where he worked. Tragedy struck again when the hotel burned down in 1875, but the indomitable Land rebuilt a more modern hotel on the same site. With 252 rooms and the city's first passenger elevator and fire extinguisher, the hotel became an immediate success. Land bought another hotel, the State Hotel at Tenth and K Streets, and sold the Western in 1904. His new hotel, the Hotel Land, was constructed on the State Hotel site and completed in 1910.

Progress and Prosperity

Land had other business interests besides hotels, including business and residential real estate within the city of Sacramento and agricultural investments outside the city limits. He was an early president of the Sacramento Chamber of Commerce and was elected mayor of Sacramento in 1897.

William Land died on December 30, 1911, only a year after the opening of the hotel that bore his name. Lacking heirs, he left the bulk of his estate to churches, convents, orphanages and charitable organizations. He also bequeathed $250,000 to the City of Sacramento to purchase a public park. The location was unspecified, starting a fierce competition regarding where the park should go. Some members of the chamber of commerce suggested buying PG&E's privately owned Joyland Park in Oak Park or renaming the recently acquired Del Paso Park after Land. This debate continued until 1922, when the site of William Land Park was chosen, the Swanston-McDevitt lot south of Sacramento. The park's creation spurred suburban development around the new park site.[64]

During the late nineteenth century, the social roles of women were often as restrictive and stifling as the corsets and bustles of the era that were designed to make women conform to an idealized stereotype of womanhood. Despite these barriers, some women found important roles to play in their community. Sarah Clayton, wife of a Sacramento physician, became a living symbol of Progressive politics from a woman's perspective in the city of Sacramento.

Born in Delaware in 1826, she became a schoolteacher in Bucyrus, Ohio, in 1846 and married Dr. Marion Clayton in 1851. In 1859, Dr. Clayton set out for California, leaving Sarah and their four children in Ohio. Rather than sit at home awaiting her husband's call, Sarah became involved in philanthropic work. During the Civil War, Sarah worked for the Sanitary Commission, an organization dedicated to promoting modern sanitation methods in army camps and hospitals. Practices like bathing regularly, disposal of garbage and sewage and washing clothes were still very new ideas in the 1860s. Even doctors performing surgery seldom gave a thought to clearing viscera off the operating table or washing their hands before surgery. The Sanitary Commission served as hospital orderlies and trained medical staff and military commanders in disease prevention and sanitary techniques. The result was a profound drop in soldiers' deaths from disease and infection. As secretary of the Sanitary Commission for five years, Mrs. Clayton learned about administration as well as sanitation.

In California, Dr. Clayton worked for eight years in Placerville before establishing a practice in Sacramento in 1867. Sarah and their children

The Clayton Hotel, located at Seventh and L Streets, was constructed on the site of the Pacific Water Cure sanitary hospital in 1910 by Hattie C. Gardiner, daughter of Marion and Sarah Clayton. The hotel was renamed the Marshall in 1939, but the original name lived on through the 1950s through the Clayton Club, a jazz nightclub in the building's basement. *Center for Sacramento History.*

joined him in 1870, and shortly thereafter, they established the Pacific Water Cure and Health Institute at Seventh and L Streets. This facility provided "Turkish, Russian, electric and medicated water and vapor baths" to its patients. This facility combined Dr. Clayton's medical skills with Sarah's knowledge of sanitary principles. As a hydropathic physician in her own right, Sarah continued the management and operation of the Pacific Water Cure after Dr. Clayton's death in 1892.

Sarah found Sacramento an ideal place to pursue the goals of improved public sanitation. She noted the poor and unsanitary condition of the county hospital at Tenth and L Streets and convinced the county board of supervisors to establish a new county hospital on Stockton Boulevard, the current site of UC-Davis Medical Center. In addition to sanitation, Sarah was very involved with local orphanages. First a director for Sacramento's Protestant Orphanage, she later established the Sacramento Foundlings' Home, later renamed the Sacramento Children's Home.

Progress and Prosperity

While social prejudices limited women's careers greatly during her lifetime, women like Sarah Clayton rose above these limitations to make a difference in their communities and express their talents and intelligence. Many of these endeavors were considered "women's work," like childcare, nursing and teaching. Women like Sarah transcended traditional gender roles and influenced politics and policy on a local and sometimes even national scale. They also helped promote women's suffrage by training a generation of young women in administrative and organizational skills and by encouraging their involvement in local political and social issues. Sarah Clayton died in 1911, the same year women gained the right to vote in California.[65]

O-fu: Progress and Prosperity in Japantown

As new laws forbidding Chinese immigration went into effect, cultural changes in Japan allowed a new wave of Asian immigrants into the United States. Prior to 1884, Japanese workers were forbidden to leave Japan, and only a handful of Japanese had visited California. In that year, an agreement was signed between Japan and the United States to allow labor immigration, primarily for sugar plantations in Hawaii. By 1890, over one thousand Japanese lived in California, and communities like Sacramento's Japantown appeared. The period of legal Japanese immigration was brief, ending with the 1907 Gentleman's Agreement that prohibited further immigration of laborers. The first waves of Japanese laborers were overwhelmingly male, but the wives and children of Japanese workers in the United States were allowed to immigrate. Until further changes in immigration law were enacted in 1924, many Japanese women immigrated as "picture brides," entering into arranged marriages with workers already in the United States. The gender imbalance was corrected quickly, and this first generation of Japanese immigrants, or *Issei*, soon produced a second generation of American-born Japanese, or *Nisei*.[66]

Sacramento quickly acquired the nickname "Sakura-mento" among Japanese immigrants. The *Sakura*, or cherry blossom, was a symbol rich with meaning for the Japanese, and their name for the Japanese community reflected this connection and its meaning. The Chinese character for "sakura" was sometimes pronounced "o," and the term "fu" meant "capitol"; Sacramento then became *O-fu*, "cherry blossom capitol." The first Japanese laborers arriving in Sacramento discovered they were not welcome

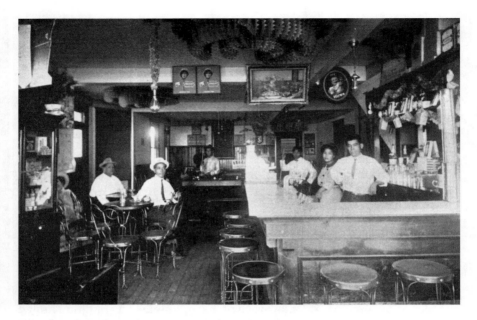

Tametaro Kunishi Soda Fountain and Billiards, 1230 Second Street, part of O-fu's business district. *Center for Sacramento History.*

in white boardinghouses, but by 1891, Sacramento had its first Japanese boardinghouse, the Tamagawa Inn. By 1909, there were thirty-seven boardinghouses in the newly established Japantown. From a population of 51 in 1890, Sacramento County's Japanese population had reached 5,800 by 1920, the largest in the state except for Los Angeles (nearly 20,000.) Sacramento County's considerably smaller population made Sacramento the most Japanese county in California. Japanese immigrants operated farms in rural communities like Florin, Perkins, Mayhew and Sutterville, while Japantown emerged between L and P Streets between Second and Sixth. The northern edge closest to K Street dealt the most with the rest of Sacramento, but a separate business district emerged along M Street that served Japantown's needs more directly.[67]

Established prejudices and racial barriers separated Japantown from the mainstream of Sacramento life. The 1922 *Ozawa v. United States* Supreme Court case declared that Issei could not be naturalized as American citizens, and California's 1913 Alien Land Law prohibited "aliens ineligible for citizenship" from owning land in California, a category that included all Asian immigrants. The size of Sacramento's Japanese population was large enough for a level of relative autonomy, aided by *kenjinkai*, social organizations

based on the immigrants' home prefecture in Japan, and religious institutions including a Buddhist temple and Tenrikyo, Presbyterian, Episcopal and Methodist churches.

Ofu Kinyu Sha (Japanese Bank of Sacramento), Japantown's first bank, opened in 1905 at 1007 Third Street, between J and K Streets. The first store selling Japanese goods opened in 1893, and by 1909, there were twelve grocery and general stores in Japantown, thirty-seven hotels, thirty-six restaurants, twenty-six barbershops, nine furnishing stores, three tofu makers and even a movie house, the Nippon Theatre on L and Third Streets. In 1913, druggist Tsunesaburo Miyakawa opened a Japanese hospital, Eagle Hospital, and later Agnes Hospital at 1409 Third Street in 1922, due to his dissatisfaction with treatment of Japanese at Sacramento's county hospital.[68]

THE SACRAMENTO BARRIO

Japantown was not the only ethnic community south of K Street. Ernesto Galarza, born in the Mexican village of Jalcocótan, left Mexico in 1910 and came with his family to Sacramento, moving into a boardinghouse at 418 L Street. He described the end of town nearest the river as a mix of many nationalities. In addition to Chinatown and Japantown on both sides of K Street, he noticed the growing barrio of fellow refugees escaping political turmoil in Mexico, a small Filipino community and even a group of immigrants from India. The Indian community included "Big Singh," a Sikh cook whom Galarza befriended despite their language barrier when he noted the similarities between the Indian *roti* flatbread and a Mexican tortilla.

Galarza's childhood and adolescence in Sacramento revolved around the economic necessity of immigrants to take advantage of every opportunity for work and his enculturation through the Lincoln School, located at Fourth and P Streets. Sacramento's immigrant communities were generally not large enough to justify separate public schools, so Lincoln School was highly racially integrated and, according to Galarza, encouraged multiculturalism and mutual respect. Teachers, led by principal Nettie Hopley, taught students American language, history and culture but never discouraged them from speaking their native languages or expressing their nation's cultural practices. Galarza described Lincoln as "not so much a melting pot as a griddle where Miss Hopley and her helpers warmed knowledge into us and roasted racial hatreds out of us."

Sacramento's K Street

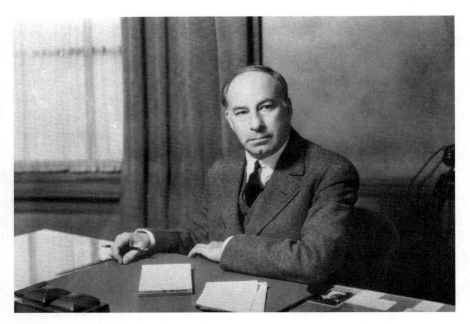

Simon Lubin, president of Weinstock & Lubin Department Store and son of the store's co-founder, David Lubin. Ernesto Galarza's meeting with Lubin left a strong impression on Galarza, prompting his career as a labor activist. *Center for Sacramento History.*

As a teenager, Ernesto spent his summers working on farms and experienced firsthand the problems of migrant workers, a multicultural population with a growing number of Mexican immigrants. Because of his eloquence and skill with language, he was often asked to represent workers when dealing with authorities. In approximately 1920, Ernesto worked at a hop farm near Folsom, where several children were sickened by the polluted water from a drainage ditch that served as the workers' water supply. One child had already died as a result, and Ernesto was asked to speak to a representative of the state labor board, Simon Lubin, son of department store founder David Lubin. Ernesto visited Simon Lubin at the Weinstock & Lubin Department Store on K Street. He explained the problems at the camp to Mr. Lubin, expecting little in the way of direct help, but with a result that surprised young Ernesto.

> *He heard me out, asked me questions and made notes on a pad. He promised that an inspector would come to the camp. I thanked him and thought the business of my visit was over; but Mr. Lubin did not break the*

Progress and Prosperity

handshake until he had said to tell the people in the camp to organize. Only by organizing, he told me, will they ever have decent places to live.[69]

In response to this meeting, Ernesto made his first organizing speech, and the workers voted to stop work until the inspector arrived. The inspector came, bringing a water tank to supply clean water to the camp. Ernesto was fired shortly thereafter by the contractor, but this activity began Galarza's career as a labor activist and union organizer.

CHAPTER FOUR

K Street Jazz

The Days of '49 Celebration

The 1920s was an era of economic vitality for Sacramento. A new city charter was adopted in 1920, replacing the short-lived 1911 city commission charter that followed the 1893 strong mayor charter. The 1920 charter created a council-manager form of government with an elected city council and mayor and city departments led by a professional manager. Like the 1893 charter, this government form was modeled after corporate forms of its own era, with an appointed chief executive officer hired by a board of directors and president. After emerging from the First World War and the 1918 influenza epidemic, Sacramento, like the United States, stood on the edge of an economic boom.

In August 1921, Arthur Dudley, secretary-manager of the chamber of commerce, outlined an idea for a citywide celebration to encourage business and tourism and help unite the city's political factions in the wake of the new city charter. Planning was spurred by rancher Edgar Simpson, attorney Cliff Russell and William Elliot, whose Chevrolet dealership was located at Fourteenth and K Streets. The date was set for May 23–28, 1922, and the event was christened "Days of '49."

Intended to recapture the spirit of California's gold rush, the event was based on a temporary theme camp established on top of the final portion of China Slough, which was finally filled in 1910. This camp mixed elements of Sacramento's past as a gold rush trade center with elements

The Eastern Star Temple at 2719 K Street was constructed in 1928 as a meeting hall for this Masonic-affiliated women's organization. The building was funded by private subscription. This drawing of the building by architects Coffman, Salsbury & Stafford shows women in contemporary dress, demonstrating the building's role as a place for the independent, modern women of the 1920s. *Center for Sacramento History.*

of popular fiction and America's growing infatuation with images of the Old West.

One of the strangest features of the Days of '49 event was the creation of the Whiskers Club of Camp '49, or "Whiskerinos," a citywide beard-

growing contest. Clyde Seavey, the first city manager of Sacramento under its new charter, was Chief Whiskerino. Arthur Dudley served as manager of the Whiskerinos, and eventually thousands of Sacramento men participated. They incorporated with the State of California on May 19, 1922, just a few days before the Days of '49 celebration began. Despite their inability to grow beards, a women's auxiliary club, the "Whiskerettes," was incorporated two days later. The Whiskerinos began a nationwide search for the man with the longest beard in the country, to be received as the guest of honor at the final beard-growing contest. The rules of the contest were:

1. Contestants had to be clean-shaven on St. Patrick's Day, March 17, 1922. Every contestant had to submit a certificate signed by a Sacramento barber that he was shaven on the opening day of the contest. Contestants would be handed membership cards and handsome buttons designating the wearer as a member of the Whisker Club.

2. Hair tonics could be used as desired.

3. First prize for the longest beard grown between March 17 and the end of the Days of '49 Celebration would be a cash prize of forty-nine dollars.

4. Merchandise prizes would be given to winners of categories, which included neatness of appearance, longest mustache, best-looking whiskers, most brilliantly colored whiskers, best imitation of sagebrush, length, luxuriance of growth, etc.

5. Contestants were to line up at the mining town on the second day of the celebration to be inspected by the judges. The three judges were the president of the Barber's Union; Mrs. Helen Gilmore, president of the Women's Council; and Clyde Seavey.

International newsreels captured the charter members of the Whiskerinos being publicly shaved in front of the post office at Seventh and K Streets on March 17, 1922. Events through the spring of 1922, including appearances at regional baseball games, promoted Days of '49 throughout California. Participation was so strongly encouraged among Sacramento men that a smooth face was considered a high crime, and an informal Whiskerino jury, the Kangaroo Court, handed out sentences to clean-shaven Sacramentans. Seavey sent memos to city employees requiring them to grow beards.

K Street Jazz

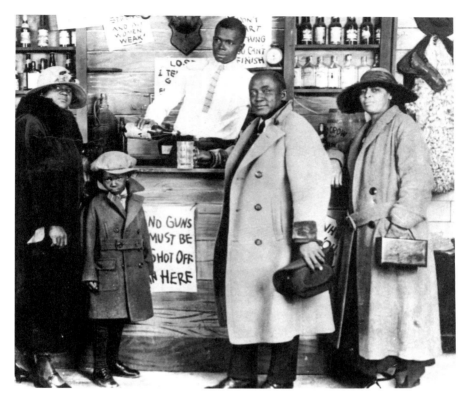

A family enjoys a photo opportunity at the 1922 Days of '49 celebration. Despite the prominent display of bottles, no liquor was sold at the celebration. This policy was enforced by the "Women's Secret Service System," a special committee intended to prevent the celebration from being overrun with illegal liquor. *Center for Sacramento History.*

The final contest raised more than $7,000. The winner of the $49 prize was C.C. Bennett, a laborer at the Western Pacific Shops, whose beard measured $1^{11}/_{16}$ inches. The King and Prince of Whiskerinos, winners of the nationwide search for the longest beard, were Hans Langseth of North Dakota, with a 17-foot beard, and Zack Wilcox of Nevada City, California. Langseth was awarded an engraved gold medal by Governor Stephens.

The Days of '49 event was a great success, with attendance for the five-day celebration estimated as high as 100,000. In addition to the encampment on I Street and a rodeo at the state fairgrounds, the event was topped with a grand march on K Street. Some Sacramentans wanted to permanently keep the mining town after the event ended, but the chamber of commerce decided against it, and all remnants of the celebration were erased. In 1926, a new

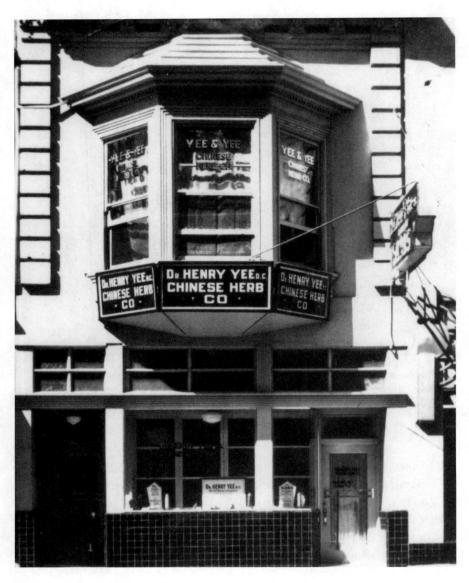

Dr. Henry Yee, grandson of Chinese immigrant Yee Fung Chung, studied civil engineering and worked in China, returning to Sacramento in 1927. Unable to find work as an engineer, he opened his own herb store at 707 J Street. His son Herbert studied dentistry and later used the same address for his dental practice. *Center for Sacramento History.*

K Street Jazz

Southern Pacific Passenger Depot was completed on the Days of '49 site, atop the former location of China Slough. The Whiskerinos continued as an organization, breaking into smaller chapters and gathering occasionally. They returned in full force in 1939 for another citywide celebration of Sacramento's gold rush heritage called Roaring Camp.[70]

Alcohol Prohibition in Sacramento

In addition to new methods of urban planning, women's suffrage and opposition to railroad and other business monopolies, alcohol prohibition was a major Progressive goal. That goal was achieved by the Eighteenth Amendment, also known as the Volstead Act, and its California parallel, the Wright Act. The Volstead Act went into effect on January 16, 1920, but the Wright Act stopped legal liquor sales in California on July 1, 1919. According to the *Sacramento Bee* the previous day, local taverns planned a grand farewell for King Alcohol and his prime minister John Barleycorn by stopping sales promptly at midnight. Despite these new laws, the liquor never stopped flowing on K Street.

Initially, many beer and wine producers supported Prohibition, assuming that low-alcohol forms of wine and beer were still permitted, but they too were shut down by the Wright Act. In a city with many beer and wine manufacturers and a downtown district dedicated to entertainment, the transition from legal taverns to illegal speakeasies was predictable. Many of Sacramento's business leaders, otherwise firmly footed in Progressive goals, were deeply involved in the liquor trade and production of beer and wine. The massive Buffalo Brewery switched to production of soft drinks and near beer, and local wineries either shut down entirely or switched to production of grape juice and syrup. Some winemakers turned syrup manufacturers marked their bottles with cautionary instructions warning customers to avoid storing the syrup for long periods, lest its contents illegally ferment. Some manufacturers were able to produce alcohol for medicinal purposes. On May 11, 1923, a group of Sacramento doctors wrote editorials in the *Sacramento Bee* supporting doctors' rights to prescribe unlimited "medicinal alcohol" prescriptions to patients.[71]

While enforcement of alcohol prohibition in Sacramento was rare, it was not unknown. Sacramento's federal Prohibition office was located in the 1895 post office at Seventh and K Streets, and these federal agents carried out raids in conjunction with local police until the office's closure in November 1925. Remaining Prohibition agents consolidated their

Sacramento's K Street

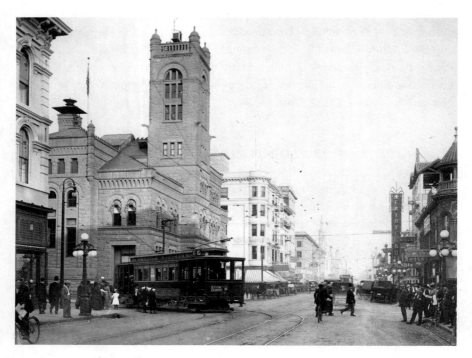

The building on the left is a post office, constructed at Seventh and K Streets in 1895 on the same site as the old St. Rose of Lima Church. Federal Prohibition agents based their offices here but had little effect on the multitude of speakeasies located within a block of this site. *Western Railway Museum.*

Northern California offices in San Francisco, so while federal raids continued, they were organized from a much greater distance. This may have provoked a sigh of relief from Sacramento bootleggers, as there were multiple speakeasies within a block of the Prohibition office at Seventh and K Streets. Liquor raids reported in the *Sacramento Bee* were generally within a block of K Street in the business district.[72]

Ancil Hoffman was one of Sacramento's most prominent businessmen. He operated avocado farms and other agricultural investments but also owned and operated multiple restaurants and saloons in Sacramento. His first saloon was opened in 1906 at 1801 Capitol Avenue, and he opened another at 708 K Street in 1912 named the Ancil Hoffman Saloon. This facility became a nightclub and restaurant, attracting entertainers like Al Jolson and other early performers of the Jazz Age. With the arrival of Prohibition, alcohol sales were halted in theory but, reputedly, never in practice. Hoffman renamed his saloon at 708 K the Hoffman & Chartier

Restaurant, appearing in city directories through 1923. He was arrested once in January 1926 on bootlegging charges, but the charges were dropped a few days later.

Hoffman was also a boxing promoter, eventually becoming one of the best-known fight promoters in the boxing world. He owned a boxing ring called the L Street Arena, located at Second and L Streets, also used by the Japanese community for sumo tournaments. Hoffman's best-known fighter was Max Baer, a fighter as legendary for his sense of humor as for his broad shoulders and devastating punch. Hoffman retired in 1942 and entered local politics, serving on the Sacramento County Board of Supervisors from 1950 to 1965.[73]

Another prominent Sacramentan who caught the eye of Prohibition authorities was August Ruhstaller, manager of Warren O. Bowers' Capital Hotel at Seventh and K Streets. The son of Captain Frank Ruhstaller, a major investor in the Capital Hotel and one of the city's most prominent brewers, August grew up in the brewing business as a shipping clerk and salesman, while his brother Frank Jr. became the general manager of the Ruhstaller Brewery and later the consolidated Buffalo Brewery, shuttered by Prohibition except for near beer and other non-alcoholic beverages. On March 12, 1925, the *Sacramento Bee* reported a raid on the Capital Hotel, part of a massive series of over one hundred raids, and a warrant issued for Ruhstaller after finding bottles of whiskey and gin in his desk. The March 13 *Bee* reported charges filed against Ruhstaller and that he had served on multiple juries prosecuting others for violation of alcohol laws. August claimed the bottles were found in hotel rooms, and he simply forgot that they were stored in his desk.[74]

Newspaper reports of the era contain stories of raids of all sizes. Some were small-time arrests of "hip men," who carried flasks of alcohol in their hip pockets, dealing drinks as ordered. Others were massive coordinated raids at multiple sites, but in Sacramento, most raids happened within a few blocks of K Street, often close to the waterfront where alcohol could be smuggled into Sacramento via the riverboat docks and railroad yards. Other raids uncovered illicit local production. In December 1925, a raid on the home of K. Yamasaka on Riverside Road uncovered four hundred gallons of sake mash. Mr. Yamasaka directed police to 318 M Street, a Japanese restaurant then owned by S. Takeuchi. Police found thirty gallons of locally produced sake on the premises and arrested the proprietor.[75]

The end of Prohibition in California came on December 6, 1933, with repeal of the Volstead and Wright Acts. According to newspaper accounts,

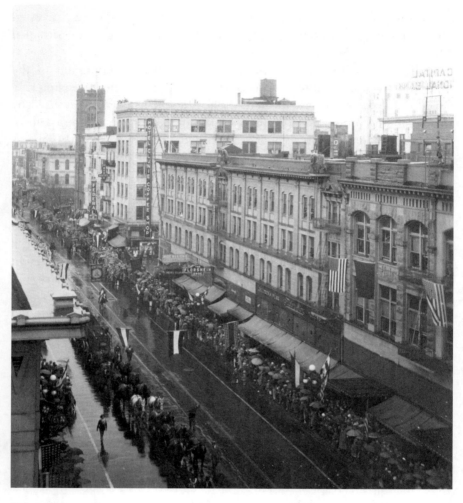

K Street was soaked by rain during the inaugural parade of James "Sunny Jim" Rolph on January 6, 1931, but it could not dampen Rolph's spirits. In his inaugural speech, he said "I feel that the greatest blessing which could possibly come upon us all is this bounteous rain." As the state was facing both the Great Depression and a drought, the crowd appreciated his sentiments. *Center for Sacramento History.*

there were relatively few public celebrations to ring in the return of legal alcohol. With the return of legal alcohol sales and licensing of taverns, the end of Prohibition may have resulted in the closure of more speakeasies than the combined efforts of Prohibition agents over thirteen years.[76]

K Street Jazz

Dancing girls on bicycles at the Fox Senator Theatre, 912 K Street, circa 1924. *Center for Sacramento History.*

Sacramento's Moviemaking Era

As the popularity of movies grew across the United States, California's moviemaking industry boomed in Los Angeles. Its combination of year-round good weather, variety of available terrain and large workforce made filmmaking a major regional industry. But not every sort of terrain was available in Hollywood, and special effects of the era could not reproduce every possible situation. Location scouts seeking a site for movies set on a large river often chose Sacramento, especially if the movie called for steamboats. Between 1914 and 1935, forty-five feature films were shot in and around Sacramento, 78 percent of which contained river scenes. More than half used the Sacramento River and its riverboats to film Mississippi River scenes.

Riverboat movies became a popular subgenre in the 1920s, perhaps due to nostalgia for a simpler era in American history. Using the Sacramento and its riverboats to portray Mississippi River scenes had many logistical advantages. Sacramento was far closer to Hollywood and enjoyed drier weather. The river was grand enough and wide enough to play the Mississippi, the Yangtze River in China and the Irrawaddy River in Burma. Director Cecil B. DeMille even

utilized the Sacramento Valley's thick tule fog in *The Volga Boatman*, shooting river scenes on location in November 1925 to simulate a dreary Russian winter. The picturesque small towns of the Delta provided occasional backdrops, but most were manufactured sets, facilitated by Sacramento's large, mobile labor force and employment agencies.

Sacramento's transportation network also provided advantages for movie makers, including fast trains to deliver film rushes back to Hollywood for editing and routes into the Sierras for films with mountain settings. Both were utilized by Charlie Chaplin for films like *The Gold Rush* and *Winds of Chance*. Both films also hired hundreds of West End migrant workers as extras for crowd scenes. Buster Keaton's *Steamboat Bill Junior* utilized over one thousand local extras to populate the fictional town of River Junction, built on the levee's edge on the Yolo County side of the Sacramento River. Southern Pacific Railroad also helped filmmakers by providing antique steam locomotives for railroad-themed films, including the C.P. Huntington, an 1863 vintage steam locomotive kept at the Sacramento shops as a sort of mascot. Some production companies even used historic artifacts from Sutter's Fort as models for props used in period films.

Sacramento's chamber of commerce actively solicited Hollywood business and functioned as a resource center for visiting producers, helping to coordinate film sites, supplies, hotels and other equipment, and the chamber of commerce auditorium sometimes served as a location of casting calls. Most of these Hollywood dollars went into the local economy, hiring workers for everything from set construction to crowd scenes, and local businesses provided lumber, accommodations, food and other materials. K Street's department stores, including Breuner's, Hale's and Weinstock & Lubin, became a source for set furniture and wardrobe for film productions.

Sacramento's bootleggers and speakeasies also benefited, and the city's reputation for ignoring Prohibition was another incentive for Hollywood studios to choose Sacramento. Los Angeles's blue laws and prohibition enforcement were more strictly enforced than Sacramento's. Visiting filmmakers were often surprised by their visit to what many Angelenos considered a quiet Delta town; producer Rupert Julian told the *Sacramento Bee*, "I was surprised to find Sacramento a big, throbbing, progressive city."[77] Dance halls like the Dreamland Dance Hall at 915 Sixth Street, the Equipoise Café at 415 K Street, elegant hotels like the Senator at 1121 L Street (completed in 1924) and the ever-present speakeasies provided Hollywood visitors with entertainment, comfort and lubrication.

K Street Jazz

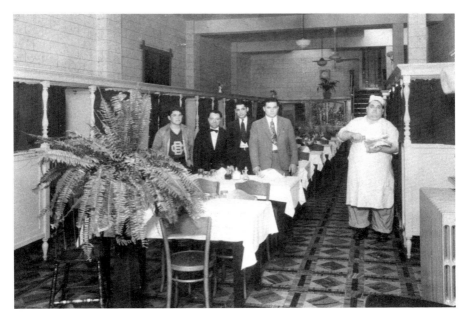

La Rosa, an Italian Restaurant at 813 L Street, was opened in 1927 by Settino "Sam" D'Allesandro. This photograph, taken in approximately 1930, shows the restaurant's dining room. *Center for Sacramento History.*

By the mid-1920s, chamber of commerce secretary Irving Engler and director John Clecak formed a committee to attract a full-time motion picture company to Sacramento. This effort resulted in several short-lived experiments in local independent film production, including the Sacramento Film Corporation, Sacramento Stereoscopic Productions and Lincoln Studios, a Los Angeles company that relocated to Sacramento in 1922. However, the nature of the film industry during the 1920s changed from the early days of small, independent companies to a handful of gigantic production studios. The studio system crowded out smaller production companies like Sacramento's fledgling independent film industry. By the 1930s, the steamboat genre had less appeal, and the greater resources and special effects budgets of the era made Sacramento's scenic proximity less important. Finally, the end of Prohibition meant Sacramento could no longer draw Hollywood stars as a place where alcohol still flowed freely. A few more steamboat films were shot in Sacramento into the mid-1930s, but after 1935, Sacramento's filmmaking era was essentially over.[78]

Sacramento's K Street

From Nickelodeons to Picture Palaces

Moviemaking was big business in Sacramento in the 1920s, but so was moviegoing. In 1923, the Clunie Theatre was demolished for an expansion of the Hale's Department Store next door. A former Turn Verein hall at 912 K Street received a $500,000 remodel, opening in 1924 as the Senator Theatre, designed by architect Leonard Starks and built by local banker George Peltier. The Senator's entrance hall ran all the way to the alley between K and L Streets, with the theater accessed by a passageway over the alley. Above the theater lobby was the Trianon Ballroom, an elegant dance hall. Five thousand people arrived for the Senator's opening festivities, three thousand more than the theater's holding capacity. The opening program featured *The Only Woman*, starring Norma Talmadge, the dance company of Fanchon & Marco and house band Walter Kline and his Syncopating Senators. Not to be outdone, the nearby Hippodrome received another remodel in 1928.

In 1927, even the beautiful Senator was overshadowed by another theater built by George Peltier and designed by Leonard Starks, located at the eastern edge of K Street. With a total cost of $1 million, this theater was designed specifically for use with Vitaphone, a new technology that synchronized sound with films—Sacramento's first "talkie" theater. The exterior was designed to resemble the Alhambra in Spain, surrounded by landscaped

The Alhambra Theatre, which sat at the foot of K Street, was constructed in 1927 by Sacramento banker George Peltier and designed by local architect Leonard Starks. Its cross-street, Thirty-First Street, was renamed "Alhambra Boulevard" in the theater's honor. *Center for Sacramento History.*

Built in 1931 and designed in the Zig-Zag Moderne style by architect John Fleming, Kress was part of a national department store chain. *Center for Sacramento History.*

Sacramento's K Street

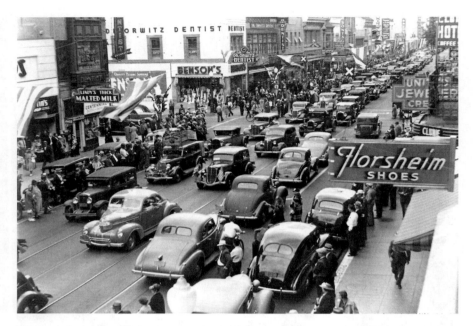

Traffic during major celebrations like the California State Fair, such as in this photograph taken during the 1939 Roaring Camp centennial, often reached epic proportions. *Center for Sacramento History.*

gardens and fountains. The interior of the theater was equally elegant. Opening festivities featured a pipe organ concert, a dedication by Peltier and California governor Clement C. Young, short film subjects and Vitaphone features and a revue of Cecil B. DeMille stars that included a young dancer named Sally Rand. The twenty-four-piece orchestra at the Alhambra was led by Uzia Bermani, a student of Russian composer Sergei Rachmaninoff. The opening program described his entire orchestra as Russian, but most were local Sacramento musicians under Bermani's leadership. While it was located at the farthest end of K Street, the Alhambra Theatre was visible from downtown Sacramento, over a mile away.[79]

Betty Inada and the Japanese Jazz Scene

How did a Sacramento girl become the most popular jazz singer in Japan? The story of Betty Inada began in Sacramento's Japantown. Like many Nisei, the first generation of American-born children of Japanese immigrants, her

life was caught between the traditions of her parents and the culture of their adopted country. Born on November 10, 1913, her parents named her Fumiko but gave her the nickname "Bessie," which she disliked and later changed to "Betty." This independence characterized her life, and by the times she was in her teens, she fell in love with jazz. In the 1920s, jazz was wild, disobedient music considered responsible for the downfall of American morals, but kids like Betty loved it. Adopting flapper fashions, such as bobbed hair with celluloid barrettes and short skirts with rolled-down stockings, Betty's style shocked her parents and more traditional Nisei youth but made her a popular figure in the local jazz scene. Like many of her generation, Betty embraced American styles and the exciting world of American jazz, fashions and films.

Sacramento's Japantown was large enough to have its own bands, like Richard Okumoto's Night Hawks. Okumoto, born in Hawaii, named his first band Richard's Original Syncopaters Orchestra and, briefly, The Mikados. His original bandmates were mostly high school students. Later members of the band included Richard Hamada (tuba), Wesley Oyama (trombone), Clem Oyama (trumpet), Henry "Pete" Tanaka (drums), Henry Onishi (tenor sax), Raymond Okumoto (banjo) and Smoky Kumamoto (piano), all led by Richard on saxophone and clarinet.

The M Street Café was a Japanese-operated Chinese restaurant with a tiny dance floor that became the favored club of Nisei hipsters of the 1920s. The location of the M Street Café was probably 318 M Street, site of the December 1925 sake raid, a restaurant owned by Umesaburo Okabe, who also owned the Hotel Rover at 226½ K Street. Night Hawks member Bill Nikaido described it as a vacant room next to the main dining room, where they played New Year's Eve and other holiday dances. The Night Hawks sometimes played at the home of Dr. George Iki, who owned a spacious house on Eighth Avenue. They also played at community clubhouses, such as the Oak Park Clubhouse, William Land Park Clubhouse and the Tuesday Club, and sometimes toured nearby farm towns with Japanese communities like Florin and Walnut Grove, shocking and delighting Nisei farm kids with their big-city sounds.

Young women like Elizabeth Murata, a saxophone player for the Night Hawks, were a small but active part of this musical community. Richard Okumoto taught her to play, and she later joined his band, defying the community's perception that playing the saxophone was unladylike. Her love of music even drove her to stay in a shack on her father's ranch, so she could practice without disturbing the neighbors. She gave up the saxophone

Sacramento's K Street

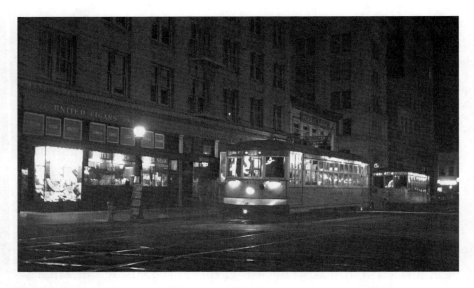

Central California Traction and Sacramento Northern streetcars met on K Street at Eighth. Because many of Sacramento's industries ran twenty-four hours a day, streetcar lines operated until late at night. *Western Railway Museum.*

in 1938 when she married. While Elizabeth Murata exchanged her musical career for family life in Sacramento, Betty Inada decided it was time to leave her home in search of stardom.

Betty Inada's mother played *samisen* and performed traditional Japanese dances, and while she may have frowned on her daughter's choice of music, she shared her love of performance. Betty joined the Los Angeles vaudeville troupe of Fanchon & Marco, but her real ambition was singing, not dancing in a chorus line or performing acrobatics as part of a stereotypical Oriental stage act. But there was little room in the United States for a Japanese lead vocalist, even in the radical world of jazz.

Betty may have been inspired by fellow Sacramentan Agnes Yoshito Miyakawa, daughter of druggist and hospital owner Tsunesaburo Miyakawa, who followed the example of Josephine Baker and moved to Paris. Agnes sang "Madame Butterfly" at the National Opéra-Comique Theatre in 1931. In early 1933, Betty's friend Fumiko Kawabata, a fellow dancer on the RKO circuit, moved to Japan to sing in Tokyo clubs. Jazz was popular in Japan, but native Japanese speakers had difficulty mimicking the swinging style of American jazz. This created an opportunity for American girls like Fumiko, native English speakers who grew up immersed in American jazz culture. This unique subculture of Japanese jazz was

K Street Jazz

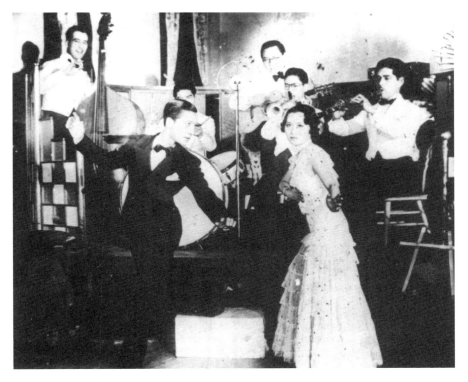

A still from *Whispering Sidewalks*, starring Saburo Nakagawa (left) and Sacramentan Betty Inada (right). *Pacific Film Archive.*

called *bata-kusai* (literally "reeking butter"). Having a friend already in Japan helped Betty ease her parents' fears about moving so far away, and on June 9, 1933, at age nineteen, she headed for Japan, despite the fact that she could barely speak Japanese.

Betty's inexperience with Japanese language and culture, and the competition from many other Nisei in Japan also seeking stardom, made her start in Japan difficult, but she found a way to set herself apart. Because microphones and electrified public address systems were still comparatively rare in nightclubs, Tokyo jazz singers often used a hand-held megaphone to be heard over the orchestra. Not wanting to hide her beauty behind a megaphone, Betty developed a vocal style more like shouting than singing. Soon she made her mark on the Tokyo jazz scene and secured a recording contract with Columbia Records of Japan. Betty's bold, brash stage performances shocked even urbane Tokyo audiences. After a hula performance at the Columbia Record Company's All-Star Cast Show, she

was visited by the Tokyo Vice Squad and charged with public indecency, accused of performing a *shiri furi dansu* ("butt-shaking dance"). She managed to explain the significance of traditional Hawaiian dancing to the vice officers, who dropped the charge.

In June 1934, Betty returned to California as a star of the Ginza club circuit. After three months at Paramount Studios in Los Angeles, she had a farewell party in Sacramento on November 7. Upon her return to Japan, she sang and danced in her first movie, *Odoriko Nikki* ("A Dancer's Journal"), followed by her starring role in *Hodo no Sasayaki* ("Whispering Sidewalks"). This musical feature film told a semifictionalized story of Betty's experiences in Japan as an American who comes to Tokyo to seek her fortune, overcoming adversity before achieving fame. This role secured Betty her place as the most popular female jazz singer of prewar Japan.

During World War II, Betty remained in Japan, teaming with popular vocalist Kazuko "Dick" Miné in 1940. Together they toured Japan and performed for Japanese troops and civilians in China and the Sakhalin Peninsula. After the war, they sang with the Stardusters, a Tokyo big band. She recorded and performed in Japan through the 1950s, gradually abandoning the brashness of her wild youth for a more mature, dignified style. Many of her songs were recorded with choruses alternating between English and Japanese, except *La Cucaracha*, which alternated between Japanese and Spanish.

Betty briefly returned to Sacramento in 1958 to open a Japanese restaurant. By that year, there was little left of the Japantown of her youth, demolished by redevelopment. Betty moved from Sacramento to Los Angeles, where she married Cecil Silva and opened a hamburger stand, later working at a photo studio. She returned to Tokyo in 1979 and 1991, both times to sing at events honoring her old stage partner Dick Miné. Betty died in November 2001, after being interviewed in 1993 for George Yoshida's book on Japanese jazz, *Reminiscing in Swingtime*. In that book, she was quoted as saying, "I have no regrets. I did what I wanted to do in my own small way." [80]

WAYNE TOM AND HIS MUSICAL MANDARINS

The Musical Mandarins, a five-man jazz combo led by Wayne Tom (born in San Francisco in 1908), toured the national vaudeville circuit from 1927 to 1929. In cities like Atlantic City and Los Angeles, they were billed as "China's Greatest Jazz Band" even though all of the band's members were born and

K Street Jazz

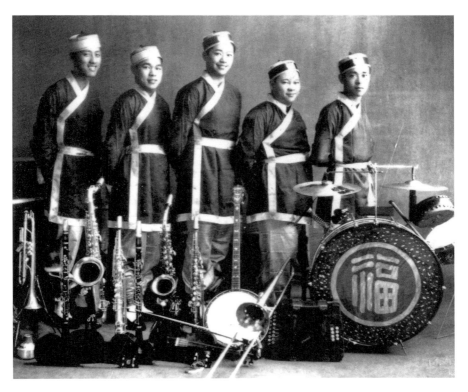

Wayne Tom and his Musical Mandarins. *From left*: David Sum, Ed Chin, Wayne Tom, Gum Lee and Harry Wong. *Center for Sacramento History.*

raised in the United States. This approach was not unusual, as many Americans not living on the West Coast had never encountered Chinese people, American-born or not. As a musical form that crossed racial boundaries, jazz gave some young Chinese Americans an opportunity to express their American cultural identity and musical talents.

While on the road, Wayne met Mabel Fong, a dancer for another Chinese American act, "Honorable Wu's All-Chinese Revue." "Honorable Wu" was born Harry Haw in San Francisco and was inspired to pursue show business by his friend Hugh Liang, a founding member of the Chung Wah Four, billed as the world's first Chinese barbershop quartet. By 1926, Harry had taken the stage name "Honorable Wu" and assembled a troupe of talented dancers and musicians, including an all-girl jazz band. Harry's traveling act, like Wayne and his Musical Mandarins, was often billed as visiting from China despite its members having American birthplaces. Mabel was a fellow

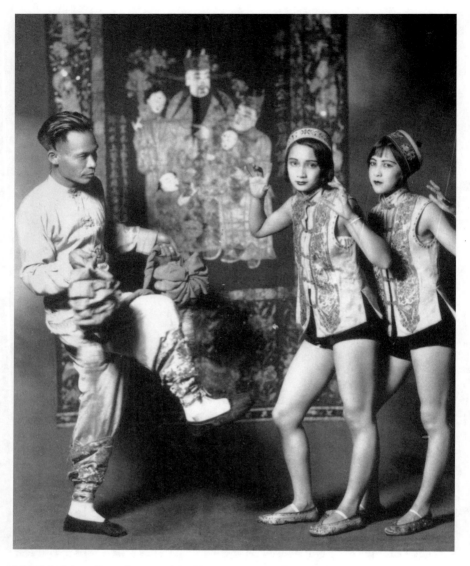

Mabel and Amy Fong, dancers with "Honorable Wu's All-Chinese Revue." *Center for Sacramento History.*

Californian, born in Oakland in 1907, who joined the "Honorable Wu" troupe, along with her sisters Amy and Pauline.

Wayne was so struck by Mabel's beauty that he married her, and the young couple moved to Sacramento in 1931, retiring from the vaudeville circuit.

K Street Jazz

Wayne started his own business, a candy and tobacco distribution company, but remained a professional musician, performing at the Hong King Lum restaurant on Third and I Streets in Chinatown and the Lok Koon Restaurant at 1015 Tenth Street. Hong King Lum was a restaurant popular beyond the boundaries of Chinatown, in part because of its food and live musical entertainment but also because of the keno games held in its basement.

Wayne, like many other businessmen of Sacramento's Chinatown, started out dealing exclusively with local Chinese-owned grocery stores but expanded beyond the boundary of the Chinese market. The business he started in a garage later expanded into a huge warehouse. Mabel became very involved in the Chinese Methodist Church and helped Wayne with his business until her death in 1981, as did Wayne's oldest son, Kenneth, who later left the business to become a social worker. In addition to his love of music, Wayne enjoyed cooking and taught this skill to his children. He was also an avid golfer, serving as president of Sacramento's Chinese Golf Association. He died in 1995.[81]

GABRIEL SILVEIRA AND BUDDY BAER

Gabriel Luiz Silveira was born on February 11, 1907, on the island of Pico in the Azores Islands. He immigrated to the United States in 1917 with his mother and two sisters and lived briefly around Freeport and Clarksburg before settling in Sacramento, where a large Portuguese community existed around Southside Park. Growing up in Sacramento, Gabe discovered his talent for music, performing lead roles and singing at St. Elizabeth's Church and the Tuesday Club. In the late 1930s, Gabriel hosted a radio show on KROY, a station that broadcasted from the corner of Tenth and K Streets in the lobby of the Hotel Sacramento. This show, called *Memories of Portugal*, featured live performances of traditional Portuguese music, and Gabriel announced the show in his native Portuguese. He later moved to KFBK, changing the theme from strictly Portuguese music to a mixture of Latin jazz and renaming the show *The Lost Gaucho*. The program continued for sixteen years. He also hosted *Music in the Latin Mood*, one of Sacramento's earliest television programs.

As a live performer, Gabriel led a big band jazz combo that bore his name, playing regularly at the El Dorado and El Rancho Hotels in Sacramento, the Club Mocambo in West Sacramento, the Argentina Café at 610 J Street, the Trianon Ballroom and The Tropics at 1019½ J Street.

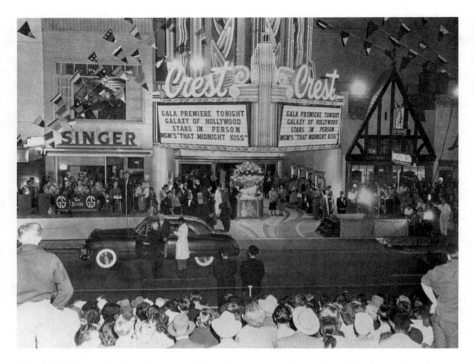

Gabriel Silveira and his orchestra performed at the grand opening of the Crest Theatre on October 6, 1949. They also headlined the after-show gala at the nearby Senator Hotel. *Center for Sacramento History.*

Opposite, top: A parade on K Street during Roaring Camp, a centennial celebration of Sacramento's founding held in the summer of 1939. *Center for Sacramento History.*

Opposite, bottom: Buddy Baer's bar at 1114 Eleventh Street attracted a devoted clientele of soldiers, lawmakers and movie stars thanks to Baer's celebrity status. *Center for Sacramento History.*

In addition to his musical career, Gabe owned a furniture store and was very involved in local and state civic organizations, especially those dedicated to Portuguese heritage. He also ran for Sacramento City Council in 1961 as part of an effort to prevent the newly planned Interstate 5 from running through the Southside Park neighborhood, the heart of the Portuguese community. He failed to secure a seat on the city council, perhaps because his busy schedule of civic participation left little time for political campaigning. Gabriel died of a heart attack on July 22, 1970, while playing golf in Land Park. Members of Musicians Union #12 played "Morning of the Carnival" and other songs at his funeral as a memorial to Gabriel and his legacy.[82]

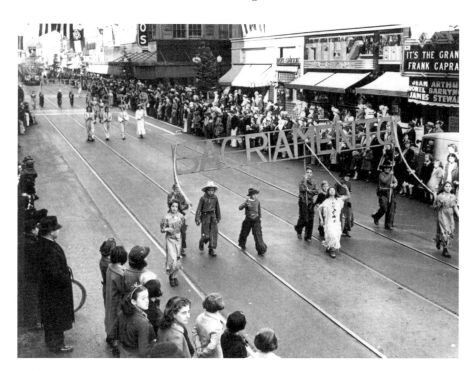

Sacramento's K Street

As the younger brother of prizefighter Max Baer, Jacob "Buddy" Baer made his own mark on the boxing world. At 6'6" and 250 pounds, he was four inches taller and 40 pounds heavier than his better-known brother, with comparable skill at boxing and theatrical flair. Ancil Hoffman saw the same talent in Buddy that he earlier saw in Max and became Buddy's manager. Buddy's boxing career lasted from 1934 to 1942, and he retired after losing a bout with Joe Louis. Following in the footsteps of his manager, Baer had purchased an interest in a Sacramento bar on Eleventh Street just north of the state capitol and gave the place his name—Buddy Baer's.

Both Baer brothers were natural showmen, well recognized for their cheerful and compassionate natures, as well as their strength and skill in the boxing ring. In addition to his gargantuan size, Buddy was a talented singer, sometimes referring to himself as "a Sinatra with weight." Partnering with restaurateur Don Ricci and boxing promoter Jackie King, he opened the 115-seat restaurant/nightclub in 1941. Buddy's place attracted legislators and state employees but also became a favorite of servicemen. During World War II, Buddy enlisted in the Army Air Corps, serving at McClellan Air Force Base, and Baer welcomed his fellow soldiers at his bar. In his autobiography, he wrote, "My bartenders were trained to remember that these were kids, most of them away from home for the first time, and most of them making their first acquaintance with demon rum." A group of soldiers stationed on a remote island in the South Pacific dubbed their improvised watering hole "Buddy Baer's II" and sent Baer a photo, which was hung reverently behind the bar until it closed.

Baer's local attraction was Helen Tvede, a beautiful and talented blond piano player, who provided the music for touring singers as well as Buddy himself. Helen also performed at Top of the Town, an elegant restaurant located on the fourteenth floor of the nearby Elks Building at Eleventh and J Streets. Baer may have missed the fame of the ring, but singing was an acceptable substitute. "And like all hams, I ate it up. I really enjoyed that bar," said Buddy. By the 1940s, Sacramento's nightclub district included dozens of dance halls, nightclubs, burlesque houses, movie theaters, bars and restaurants that stretched from M Street to J Street, from the dives and pool halls near the waterfront to elegant destinations like Buddy Baer's.

In 1949, comedians Bud Abbott and Lou Costello visited Buddy's (Lou Costello was childhood friends with Don Ricci and a frequent visitor to the club) in search of villains for their upcoming feature *Africa Screams*. They offered Buddy and his brother Max roles, which they accepted, launching

both into Hollywood careers. This move took the Baers out of Sacramento, and in November 1951, *Billboard Magazine* reported that Baer sold his interest in the bar that bore his name.

After his movie career, Buddy returned to Sacramento in the early 1970s (his brother Max died of a heart attack in 1959). He briefly worked as a movie host on Channel 31, introducing action movies, westerns and thrillers. Buddy also served as sergeant-at-arms for the California legislature, running errands and maintaining decorum in the chamber. He still carried fond memories of his nightclub years.

> *Today, when I walk by the real estate office that occupies the sacred space once known as "Buddy Baer's," I find myself blinking a little faster. The bar was more than just another drinking establishment. It was a rendezvous for lovers, a little theater for aspiring magicians and vocalists, a stage for banjo players and guys with guitars and horns, a post office address for out-of-towners, place for political intrigue…and it was Radio City Music Hall for me. I loved the place.*[83]

Baer died in 1986, leaving behind a well-known legacy as a boxer and actor and a lesser-known legacy as part of Sacramento's musical community.

Nitz Jackson and the Zanzibar

During World War II, Executive Order 9066 sent thousands of Japanese Sacramentans to internment camps. Many lost homes, businesses and property, but this tragedy became an opportunity for others. Sacramento's railroad shops maintained the locomotives and cars needed to move war materiel to the Pacific, and its massive canneries turned fresh produce into shippable, nonperishable products needed for the war effort. Thousands of African Americans came to Sacramento to fill the jobs vacated by Sacramentans who had joined the military, in addition to the thousands interned by the American government. Most of these migrants came from the southern United States. Mather and McClellan Airfields and the Army Signal Depot saw a massive influx of soldiers, and while the army was still segregated, some African American units were stationed near Sacramento. Within a few years, Sacramento's black population tripled. Some purchased businesses from the departing Japanese, opening a variety of businesses, but the best known were the jazz clubs. These clubs became so popular that they

Sacramento's K Street

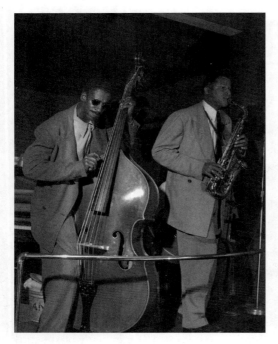

Left: On stage at the Zanzibar Club. *Keith Burns collection.*

Opposite, top: The Zanzibar attracted a large and interracial audience. *Keith Burns collection.*

Opposite, bottom: Joe Louis visited Sacramento for an exhibition match in 1947 and stayed to visit his friend Nitz Jackson, owner of the Zanzibar Club. In the photograph are an unidentified man, *Sacramento Bee* sportswriter Vince Stanich, Bill Coutts, Nitz Jackson, Joe Louis and Don "Hovey" Moore, owner of the Mo-Mo Club. *Keith Burns collection.*

crossed racial barriers and made Sacramento a stop on the touring circuit for the greatest jazz musicians of the twentieth century.

Sacramento's African American–owned jazz clubs probably started with the Eureka Club on Fourth and K, considered one of the biggest jazz nightclubs in Northern California. The Eureka Club was reputable enough for inclusion in a Sacramento guidebook aimed at tourists attending the 1939 California Centennial. But racial lines were difficult to cross in Sacramento, even if segregation was de facto, more by tradition than force of law. New arrivals from the South (where segregation was statute law) felt less restricted by California's lack of codified segregation laws The 1940s and 1950s saw the emergence of Sacramento's new African American middle class, including doctors, morticians, policemen, architects, attorneys and other professionals and business owners, as well as nightclub owners.

Louise and Isaac Anderson and William "Nitz" Jackson purchased a liquor store from a Japanese owner in 1942 and established the Zanzibar Club at 530 Capitol. The Zanzibar featured touring musicians like Dizzy Gillespie, Count Basie and Duke Ellington. Local musicians like Vincent "Ted" Thompson (who owned the nearby Thompson Mortuary) also graced the Zanzibar's stage. Across the street from the Zanzibar, the Mo-Mo Club, owned by brothers Alex and Hovey Moore, featured both dancers and

K Street Jazz

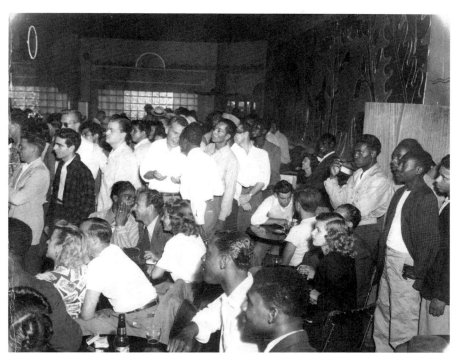

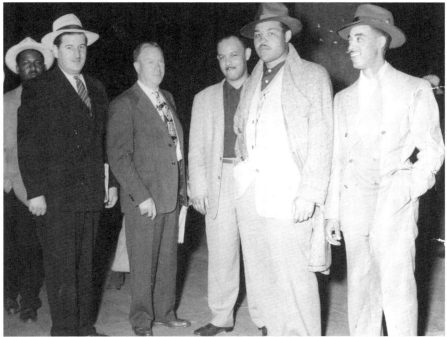

musicians. Other nearby clubs included the Congo Club at 329 Capitol, the Cotton Club at Sixth and J and the Clayton Club at 1126 Seventh Street, beneath the Marshall Hotel (originally the Hotel Clayton). The Clayton featured musicians like The Treniers, Cab Calloway and comedian/tap dancer Gene Bell. These clubs became a major part of Sacramento's live music scene in the 1940s and 1950s. Acts that outgrew the local jazz clubs played bigger shows at the Memorial Auditorium.

The widespread appeal of swing and bebop jazz drew crowds that trampled Sacramento's color line under dancing feet. While Sacramento's small population could not match the big-city jazz scenes of Los Angeles or San Francisco, strong attendance at West End clubs put Sacramento on the touring circuit of most major acts. In addition to regular weekend shows, the Zanzibar was best known for its informal Sunday afternoon jam sessions, free-form experiments that drew performers like Louis Armstrong and Dizzy Gillespie.

The success of the Zanzibar also brought negative attention. Challenges to Sacramento's long-held color line met strong resistance from established white interests. Based on rumors of prostitution at the Zanzibar, state liquor officials revoked its liquor license in 1949, effectively closing the club. Some saw the revocation as retaliation by white businessmen jealous of the Zanzibar's success. Nitz Jackson moved to Southern California after the closure of the Zanzibar. The Andersons later relocated their liquor store, A&J Liquors, to Stockton Boulevard.[84]

BOB WILLS AND BILLY JACK WILLS

In 1947, bandleader Bob Wills moved to Sacramento, purchased the Aragon Ballroom north of Sacramento and renamed it Wills Point. Wills was one of the founders of Western swing, a mixture of country music and swing jazz that was enormously popular in the 1940s. Wills, originally from rural Texas, incorporated African American musical forms, like jazz and blues, into southwestern "cowboy music" to create a new form, a precedent to early rock 'n' roll. Chuck Berry's first release, "Maybelline," was an adaptation of a country song, "Ida Red," recorded by Bob Wills.

Wills used Sacramento as a base of operations while touring the country with the Texas Playboys. He recruited his brother, Billy Jack Wills, to run Wills Point. Billy Jack was an accomplished musician in his own right and had his own group, the Western Swing Band. In addition to live performances

K Street Jazz

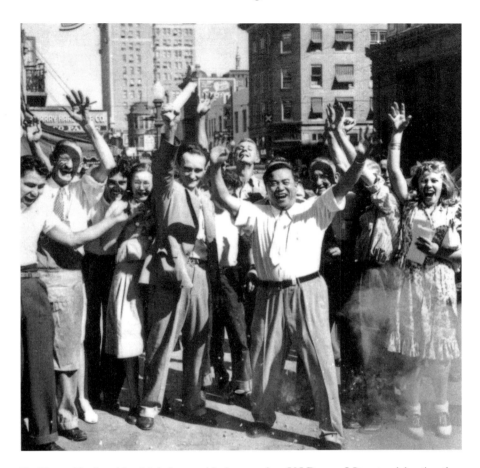

Dr. Henry Yee (in white shirt) cheers with the crowd on V-J Day on J Street, celebrating the end of the Second World War. *Center for Sacramento History.*

at Wills Point, this band played regular shows on local radio station KFBK, broadcasting from 701 I Street. Billy Jack's radio show featured prominent advertising for sponsor Standard Furniture Warehouse, located at 2018 I Street. Many of these commercial spots mentioned its warehouse's lower rent and lack of fancy displays as the source of its lower prices (in contrast to downtown furniture stores) and its plentiful free parking as opposed to fighting for space at a parking meter on K Street. Billy Jack's music blurred the line between Western swing and jazz to an even greater extent than his brother, with the help of musicians like mandolin player Tiny Moore and jazz-influenced steel guitar player Vance Terry. In 1953, Billy Jack's band

recorded a cover of Bill Haley and the Comets' "Crazy Man, Crazy," the first hit single recognized as rock 'n' roll in style. The radio show ended in 1954, and Wills Point burned down in 1956, but Sacramento kids' appetite for rock 'n' roll had just begun.[85]

Sacramento's Jazz Age musicians created an integrationist form of music, not in a deliberate political fashion but as a musical discourse, exchanged back and forth across racial lines. Racial barriers became permeable in the music world, especially in the densely populated ethnic neighborhoods around K Street, where music was often the one common denominator. This combination created an environment of great cultural richness, but the groups whose image of Sacramento challenged the multiracial, industrial nature of K Street's neighborhoods considered the lively, diverse jazz clubs of K Street a threat. As downtown Sacramento's urban culture multiplied and diversified in the wake of generations of cultural infusion, the chamber of commerce looked at K Street and its neighborhoods and called it blight.

CHAPTER FIVE

THE SACRAMENTO SCRAMBLE

Following the end of World War II, Sacramento faced another surge of growth. Flood-control projects completed between 1930 and 1950 allowed construction on former farmland. Suburban growth followed highway routes and new employment centers in eastern Sacramento County, including Mather and McClellan Air Force Bases, the Sacramento Army Depot and military contractor Aerojet-General. By 1961, 630,000 people entered or left Sacramento's central city each day. Fewer than 5 percent rode public transit. The rest took private automobiles, resulting in an enormous crush of traffic through downtown Sacramento. K Street, built during the era of the pedestrian and horse-drawn streetcar, was poorly suited for the automobile. The electric interurban railroad Sacramento Northern ceased regular passenger service in 1940, the same year that riverboat service to San Francisco ended, and streetcar service ended in 1947. Bus lines extended into the new suburbs, but the low density of suburban development made buses impractical for most of the region. Almost none of the department stores, hotels, theaters or restaurants had parking lots, so even if a motorist was persistent enough to drive to K Street, finding a parking space was an even greater challenge.

Meanwhile, new shopping centers and malls were under construction in the suburbs, starting with Jere Strizek's Town & Country Village in 1946. It was an immediate success, and its presence encouraged more people to buy homes in Strizek's nearby residential developments. Prior to Town & Country, shopping required a drive to K Street, but Town & Country

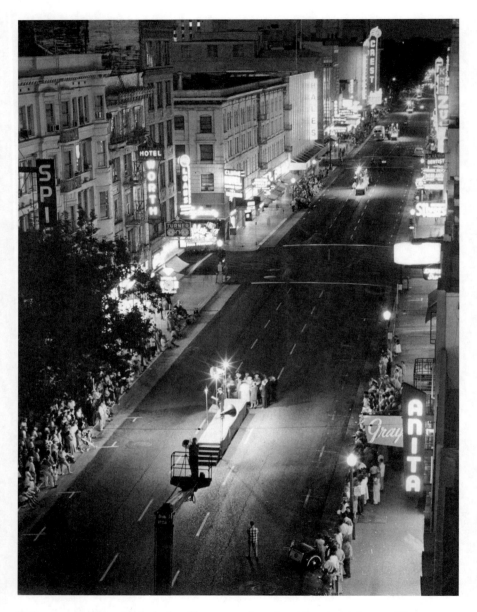

K Street was seldom this free of traffic, except when closed for a special event. The street was restriped for one-way traffic in the 1950s to ease traffic congestion. *Center for Sacramento History.*

was much closer, and parking was free and abundant. Other suburban real estate developers followed suit, creating new shopping centers and suburban shopping malls. Joseph Blumenfeld and James J. Cordano opened Country Club Centre in 1951, expanding the retail frontier farther east. These retail destinations became the center of new suburban developments.

Back on K Street, the picture was less rosy. While new employers were opening to the east of Sacramento, older industries like the Southern Pacific Shops were hiring fewer workers due to the conversion from steam engines to less maintenance-intensive diesel locomotives. The freight docks of Front Street were stilled when river traffic moved to the new Port of West Sacramento, removing a major employer from the Sacramento waterfront. The loss of downtown jobs and eastward population shift turned K Street from the center of town to a remote end of the urban region.

The West End of K Street in the 1950s

Sacramento's Japanese population returned at the end of World War II to a transformed neighborhood. Some were able to retain their property by transferring it temporarily to a family friend and were able to set up homes and shops in their previous locations. Others found temporary shelter in neighborhood churches or squeezed into the handful of vacant houses in the neighborhood. Still others relocated to other cities or the farm communities where space was available. By the early 1950s, the Italian and Portuguese residents of nearby Southside Park began moving into nearby suburbs, and some Japantown residents moved farther from K Street into Southside. The African American and Mexican populations of the neighborhood grew during the war, both from migration from the South and Southwest and from workers from Mexico who came as part of the *Bracero* program.

George Raya was born in Sacramento in 1949 but moved to a hop ranch in Wheatland with his family in 1953. During the harvest season, August and September, the hop ranch was very busy, so his parents sent him to live with his grandmother, Guadalupe Cervantes. She had moved to Sacramento in the 1930s and owned a restaurant, El Rancho, at 1222 Third Street at the northern end of Japantown. During World War II, El Rancho was popular with visiting soldiers, but the local army base posted it as off-limits until Guadalupe confronted the base commander. Citing her help selling war bonds and her sons in military service, the commander relented, especially when Guadalupe threatened to inform the *Sacramento Bee* how they had

treated a gold star mother. George spent his summers living with Guadalupe and other relatives in Sacramento, often in the West End, until 1963, when the restaurant was sold to the city's redevelopment agency. George recalls:

> *It really was kind of a mixed neighborhood. My grandmother would talk about the Japanese businesses that were next to hers. I would run down to the corner market at L and Third, it was a little Chinese-owned store. It was very compact with shelves going very high, and the owner had this pole with a handle to grab things from the top shelf. I always liked watching him do that. Filipinos, Chinese, Japanese, a really very mixed area, at one time it had been the Japanese section. Everyone lived happily together. When the second war started, my grandmother told me how she held deeds for different neighbors until they came back, who had been relocated in the camps. They were her neighbors!*
>
> *One of the reasons my grandmother was more sympathetic* [was] *because unlike other nationalities, during the Depression, Mexicans were shipped back to Mexico. They didn't ship Italians back to Italy or anything, but we were so physically close, they would load them up in railroad cars and ship them back to decrease the welfare rolls. That was happening up until the fifties.* [My grandmother] *almost got caught. They would block off the street and set up a stockade at the Southern Pacific railroad yards. They would load them, put them in a car and ship them to Mexico. One day there was a commotion outside her restaurant and she went outside to see what was going on. It was one of these raids, and someone grabbed her and put her in front of the INS people. She said, "Oh, let me get my purse, I have my papers in the restaurant," but they said "Oh, yeah, yeah, we've heard that one before!" So they took her and placed her in the stockade. One of the immigration officials walked by and recognized her, as Lupe had worked as an interpreter for them a couple of times. "Lupe, what are you doing there?" "I got picked up, they wouldn't let me go back in the restaurant!" And so they gave her a document saying she works with our department, show her all courtesy, etcetera etcetera.*[86]

George's memories of summers on K Street were limited to just a few blocks, the distance a child could walk, but within that radius were movie theaters like the Lyric and the Mission, soda fountains and hot dog stands and other attractions. He could also visit his great aunt, Anita Molina, at her Copa de Oro restaurant at 925 Second Street. In addition to summertime stays, George's family returned to Sacramento for Thanksgiving dinner at the restaurant. After the meal, George and the other kids walked to K Street, thronged with visitors patronizing theaters and stores.

The Sacramento Scramble

Shopping on K Street

For Sacramento's baby boom generation, K Street was the very essence of Christmas in physical form. On K Street, department stores like Breuner's, Weinstock & Lubin, Hale's, Kress, Roos-Atkins, Montgomery Ward and Sears competed for attention and customers during the holidays by creating elaborate display windows to draw Christmas shoppers. Many retailers focused their displays on the products for sale, hoping to attract buyers with fancy merchandise and eye-catching toys, accented by holiday decorations and images of Santa and elves. Hale's Department Store celebrated Santa Claus's arrival every year with increasingly improbable

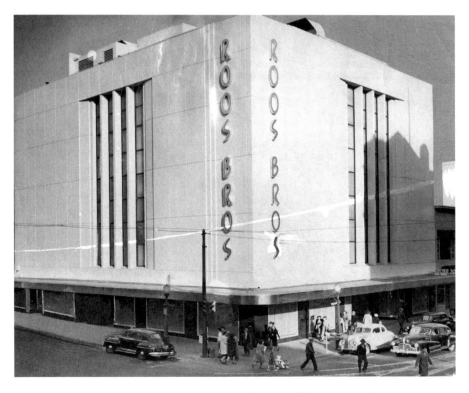

In 1946, the Roos Brothers Department Store at Tenth and K was rebuilt from the ground up. The 1902 brick building was replaced by a concrete Streamline Moderne department store. Supported by central pillars that allowed a continuous glass wall along the ground floor, the imposing concrete building appeared to float on a delicate ribbon of glass. *Center for Sacramento History.*

Sacramento's K Street

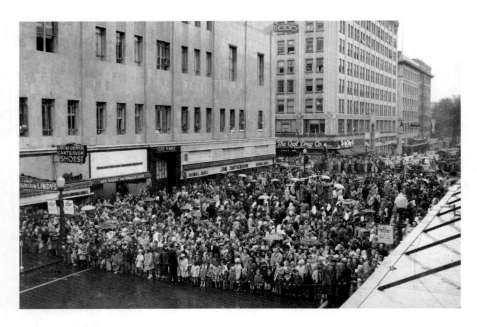

Crowds form at Ninth and K awaiting Santa's arrival outside Hale's Department Store. *Center for Sacramento History.*

This year, Santa Claus arrived on K Street via helicopter. *Center for Sacramento History.*

The Sacramento Scramble

modes of transport, like a submarine that brought Santa to K Street via the Sacramento River and a helicopter that landed directly on Ninth Street to thrill an amazed crowd of onlookers. Weinstock & Lubin preferred to let its merchandise tell the story, with displays featuring enormous arrays of gifts, toys and other goods.

Breuner's Furniture Store took a different approach. Its displays sold sentimentality and nostalgia, not products. Introduced in 1934 during the Great Depression, its displays featured life-sized animated figures enjoying the holidays in various settings, such as a quaint village, a store, a forest or at home in front of the fireplace. Figures were dressed to reflect the late nineteenth century. Their appeal to comfort and tradition, as well as their ingenious mechanical workings, attracted both young and old.

The animated figures used in Breuner's display windows were constructed by the Gaffney Display Company. Founded by Marjory Gaffney in 1936 and aided by her husband, Kenneth, and her son, Mark, the Gaffney displays brought the Breuner's displays to life with electric motors and lights. Early prototypes were created on elevated platforms, with large electric motors beneath the platform to bring the mechanical revelers to life. Later displays used newer, smaller electric motors inside the bodies of the figures, allowing easier installation and repositioning. Visiting Breuner's displays was an annual ritual for many families, and the store owners photographed each display for a Christmas postcard. Their last appearance on K Street was in 1974.[87]

Christmas was the most shopping memorable time of year, but according to Mike Munson, whose parents lived on K Street when he was born, K Street was the year-round shopping district of choice for all of Sacramento. He grew up in the neighborhood of Oak Park, where there was a small shopping district on Thirty-Fifth and Broadway, but his grandmother always preferred K Street.

> *There was shopping on J and L Street, but she wouldn't go past K. We went to movies, either the Senator or the Crest. If she couldn't afford to go to the first-run theater, we would go to the State Theater across the street, or the World or Roxie, as it was called then. She did virtually all of her shopping there, at Roos Brothers. Roos Brothers carried the uniforms for the parochial schools. We'd also go to Foreman and Clark, about a block and a half down. Her jewelry she would buy from Tom Monk, a former mayor who was also a jeweler.*

The 1936 Breuner's display featured antique furniture, not merchandise for sale inside the store. *Center for Sacramento History.*

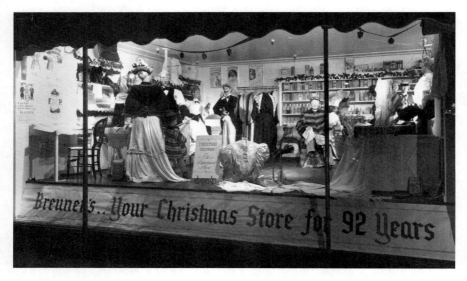

Each Breuner's display began as a reference drawing by Marjory Gaffney, while her husband, Kenneth, provided the mechanical wizardry and electrical know-how. Their son, Mark, helped even as a child, climbing into tight spaces and serving as a model for casts of child-sized hands used on the animated figures. *Center for Sacramento History.*

The Sacramento Scramble

The Esquire and Times Theatres, between Twelfth and Thirteenth Streets, were at the eastern edge of K Street's business district. The Studebaker dealership on Fourteenth marked the beginning of K Street's row of auto dealerships. *Center for Sacramento History.*

For Maryellen Burns, who was three years old when her family moved to Sacramento in 1954, K Street was defined by its specialty stores as much as its department stores. Small shops specializing in men or women's clothing, shoes, stationery, foods and other specialty items filled the spaces between large department stores.

> *K Street was Main Street, and that's where you did everything. There was nothing you couldn't get there: shoes and shoe repair, dentists, the five-and-dime, department stores, restaurants, cafés, obviously the theaters. This was before there were malls. It was very different from J Street. K Street was upscale, and J Street always seemed a bit seedier. You could even buy guns on K Street when I was a kid; there were gun shops. You got dressed up to go down to K Street; I remember having to put on my gloves and actually having to put on a hat; it was like going to San Francisco. Even then, I was very aware of what the West End was, which we loved (we loved the restaurants down there), but it's where the street life was, the entertainment.*

Sacramento's K Street

The old Golden Eagle Hotel still stood at Seventh and K in the 1950s. The Capitol and Liberty Theaters advertised all-night movies, marking the western edge of the shopping district and the beginning of the West End. *Center for Sacramento History.*

The shopping and entertainment district of K Street stretched to approximately Twelfth Street (where Weinstock & Lubin relocated in 1922) and the Esquire and Times Theatres between Twelfth and Thirteenth. The western boundary was Sixth Street, just past Breuner's Furniture. Mike Munson's grandmother warned him to never walk west of Sixth Street, where the West End began. Her love of K Street's shopping district did not include the waterfront.

K Street and L Street were Sacramento's restaurant row, ranging from inexpensive diners for working people to elegant, upscale restaurants for legislators and businessmen. Hart's, an automat near Ninth and K, was a neighborhood favorite for Maryellen Burns's and Mike Munson's parents. Frank Fat, a former waiter at Hong King Lum Restaurant (where Wayne Tom played) opened his own restaurant at Eighth and L Streets in 1939, a spot that soon became the favorite of California legislators, including former K Street resident Earl Warren and a host of other California political luminaries. Guadalupe Cervantes, George Raya's grandmother, operated her El Rancho restaurant at Third and L until 1963.[88]

The Sacramento Scramble

THE SCRAMBLE ON K STREET

In the post–World War II era, automobile ownership exploded, and automobile traffic on K Street increased prodigiously. In January 1947, the last of Sacramento's streetcars ceased operation, replaced by General Motors buses owned by Sacramento City Lines, which had purchased the streetcar line from PG&E in 1943. In 1947, Daniel J. Bennett, chief of the Sacramento Police Department's traffic division, recommended that the city council adopt one-way streets, increase off-street parking and eliminate on-street parking on the busiest streets. Bennett described the problems for the *Police and Peace Officers' Journal*: "Like other communities that have grown fast we have a traffic problem of great dimensions. There just isn't room on the streets for all the cars we have…there are 2.2 cars for every person on Sacramento. This gives us the highest per capita rate on record."[89]

Not all of Bennett's recommendations were followed, but many downtown streets were converted to one-way operation. As vehicle traffic increased, so did pedestrian traffic on K Street. In 1952, a new system called the "scramble" was introduced to cope with high rates of pedestrian and vehicular traffic. Using this system, automobile traffic was stopped in all four directions, and pedestrians could cross in either direction or diagonally. The pedestrian scramble was followed by phases of traffic with no pedestrian crossing, allowing faster right turns. According to a 1952 *Police and Peace Officers' Journal* article, it looked like pandemonium but worked effectively along practically all of K Street's busiest intersections. The idea was championed by council member and former mayor Bert Geisreiter.

K Street had been converted to one-way operation by 1955, with traffic running east to west. L Street ran from west to east, and the two streets functioned as a couplet carrying traffic through town from the Tower Bridge to Highway 40. K Street was still an important destination, despite increasing traffic congestion and limited parking spaces, but many of the cars were through traffic. The "scramble" system was maintained on the new one-way K Street, but it became less necessary as pedestrian activity slowly dropped off during the 1950s.[90]

Sacramento's K Street

Photo of civil rights activists protesting employment discrimination at the Montgomery Wards Department Store at Ninth and K Streets, circa 1964–65. *Center for Sacramento History.*

The Sacramento Scramble

THE K STREET CRUISE AND SACRAMENTO YOUTH CULTURE

As the young children who marveled at Breuner's and Weinstock's holiday displays became teenagers, they found other uses for K Street. This new postwar generation grew up with the automobile as a symbol of consumer abundance, individual freedom and personal expression. From the mid-1950s until the late 1960s, every weekend night was a parade called the K Street cruise. The cruise was not an officially sanctioned event orchestrated by the city. It was a spontaneous expression of Sacramento's young people, and sheer force of numbers gave the cruise certain traditions. It operated in a loop, running east to west on K Street, turning south at Seventh, east at L Street and then turning north again at Sixteenth by Tognotti's Firestone. One block north at Sixteenth and K was Stan's Drive-In, a circular-shaped restaurant served by carhops riding roller skates. From Stan's Drive-In, the cruise turned west again and repeated the loop. At times the cruise extended onto J Street, another one-way street running west to east, whose traffic circled back via K Street at Fifteenth. Other restaurants on the eastern end of the cruise, like the Auditorium Club at Sixteenth and J and Sam's Hof Brau at J and Seventeenth, were preferred by cruising kids, as parking was easier farther from downtown. In addition to drive-in restaurants, the middle section of K Street was dominated by automobile dealers, including Newton Cope's Buick dealership, JJ Jacobs Cadillac and Mel Rapton Pontiac. In between the dealers were auto-repair and supply stores.

According to Mike Munson, "It was generally a bunch of guys in a car or a bunch of girls in a car. Sometimes you'd see a guy out with his girl but you didn't pay attention to them." Groups of teenage boys and girls in separate cars engaged in courtship rituals ranging from subtle flirtation to crude catcalls. Pedestrians on K and L Streets, kids with no cars or those fortunate enough to find a parking space, observed the parade from the sidelines. Maryellen Burns considered the pedestrian activity more important than the cars: "Everybody thought it was all cars, but there were as many people on the street watching the cruisers as anything else. It was a place for kids to meet other people, it was a safe environment." George Raya considered the L Street side of the cruise more important than the K Street side. "You had the long Capitol Park blocks where there were no interruptions," said George. "People could stand on the sidewalk on the park side and watch everybody. I remember going with friends on L Street because you could park, you could lounge, there was all that space…Everything else was too stop-and-go."

Sacramento's K Street

Sacramento was already an important center in the world of hot rods and custom cars. Starting in the 1930s, local mechanics modified old cars with sheet-metal tools and copious amounts of lead, giving them the nickname "lead sleds." The earliest acknowledged master of the form in the Sacramento hot rod scene was Harry Westergard, who started in the 1930s. Later masters like Dick Bertolucci and George Barris grew up admiring his work, inspiring their own careers as custom car builders. Westergard died in 1956 when his customized Thunderbird flew off a Delta levee at high speed, a wreck that tore his car in half.

George Barris and his brother Sam are best known for their work on Hollywood custom cars in the 1960s, including television's "Batmobile" and the hot rod on "Munsters," but they started in Sacramento at a small shop on G Street, just a few blocks from the edge of the K Street cruise. Dick Bertolucci grew up in Sacramento and was inspired to work on cars by his father, Mario, a master mechanic. Unlike the Barris brothers, Bertolucci remained in Sacramento, and his auto body shop survived into the twenty-first century. The work of Sacramento's car customizers was an art form, and the K Street cruise was a gallery of their masterworks.[91]

Not everyone had the skills or the money for a custom hot rod, but any car was better than no car. Mike Munson's first car was a 1948 Chevrolet, a gift from his mother on his nineteenth birthday. The car was fifteen years old and in rough shape, but its value was enormous to Mike. "That was the beginning of a new life for me," he said. "I think everyone remembers their first car, especially guys." Cruising was a way to connect with other kids and with the greater community. One of Mike's strongest memories of the cruise was after the Kennedy assassination: "We got in our car; it was a rainy night, the mood of the day was very depressing. It was almost an endless night. What do we do?" In the wake of a national tragedy, Sacramento's teenagers came together on their most welcoming ground, the K Street cruise. "It was a strange, strange atmosphere," mused Mike, "I think people wanted to be around other people. 'What the heck? The president was just killed!'"[92]

K Street was home to Sacramento radio stations dating back to the city's first station, KFBK, located in the Kimball-Upson hardware and sporting goods store at 607 K Street, inaugurated on February 2, 1922. On the K Street cruise, the musical soundtrack was provided by hundreds of car radios, tuned in to local stations like KROY, whose broadcasts began in 1937 at 12:10 a.m. from a studio on the mezzanine of the Hotel Sacramento at Tenth and K Streets. The original format was big band swing jazz, including live acts like Gabriel Silveira's band. When the Hotel Sacramento was demolished

The Sacramento Scramble

to make way for a Woolworth's Department Store in 1956, KROY moved a block away to 1010 Eleventh Street, above the Country Maid ice cream parlor. By 1960, the station had switched from swing to a Top 40 format to capture the youth market, billing itself as "Color Radio." This format included doo-wop, rhythm and blues and rock 'n' roll, a continuation of the interracial musical exchange that started in the jazz era. KROY's main competitor at the time was KXOA, another Top 40 format station.

In the early 1960s, surf music was enormously popular in Sacramento, in part because the best-known surf music stars, the Beach Boys, played in Sacramento frequently. Their first live album was recorded at Memorial Auditorium at Sixteenth and J Streets, near the eastern end of cruisers' territory. Despite Sacramento's location two hours from the ocean, the Beach Boys were always a hit in the city. Sacramento bands like The New Breed were heavily influenced by surf rock. The British Invasion brought acts like the Rolling Stones and the Yardbirds to Sacramento, inspiring other local musicians like Oxford Circle.[33] Mike Munson recalled the enormous line outside the Fox Senator Theatre in 1964, waiting to see the Beatles film *A Hard Day's Night*.

While the K Street cruise was remembered fondly by teenagers of the 1950s and 1960s, Sacramento's chamber of commerce and city government saw it in a far less positive light. Teenage cruisers did not patronize K Street's department stores or specialty stores, other than the drive-in restaurants farther down K Street, making them a nuisance to downtown businesses. Business owners often complained of teenagers taking up street parking spaces and discouraging customers. The cruise limited automobile access to downtown businesses, including restaurants and movie theaters. To the police, cruising represented juvenile delinquency and street crime. According to Mike Munson, police were generous with citations for exhibition of speed in order to curb drag racing. The cruise continued until the late 1960s, when traffic was removed from K Street. As the generation of cruisers entered adulthood, many moved to the suburbs and turned their backs on the weekend tradition of cruising—and often stopped coming to K Street entirely.

West of Sixth Street:
Burlesque and Striptease on K Street

K Street featured dancing girls dating back to the canvas tents of the gold rush through the golden age of vaudeville. Many of the small theaters around

SACRAMENTO'S K STREET

Beyond the Bank of America building at Sixth and K Streets, the New Star burlesque house advertises "French Postcards" and twenty-two burlesque acts. *Center for Sacramento History.*

K Street were driven out of business by newer picture palaces, both those farther down K Street and in the suburbs. Some of these old theaters found new identities as burlesque houses and striptease clubs. As a neighborhood already populated by single working men and frequented by soldiers from nearby military bases, there was an ample local market for burlesque during and after World War II.

Nadra "Ned" Hakim, a Syrian immigrant who came to the United States in 1948, was asked to manage the Lyric Theatre at 212 K Street by his cousin Fred Naify. The theater switched to burlesque shows in about 1950, renaming itself the Nu Lyric Theatre. The previous manager had a poor reputation with local police, prompting Hakim to clean up the theater and improve its image: "My cousin Fred told me, Ned, you take it over and run it, clean it up so it won't offend anybody. I did it. We ran a clean house there."

Even local police agreed that Hakim's management resulted in fewer problems with the authorities, perhaps due to his previous experience as a police inspector in Damascus before moving to the United States. In 1955, the Lyric Theatre closed, and Hakim moved his burlesque house to the Alameda Theatre at 328 L Street. The Alameda, previously the Nippon

The Sacramento Scramble

The Alameda on L Street was called the Nippon Theatre from 1907 until 1942, showing Japanese-language films. The name was changed during World War II. In 1955, the Alameda became a burlesque house. *Center for Sacramento History.*

Theatre and Jitterbug Café prior to World War II, changed ownership and format during the Japanese internment period. Hakim operated the Alameda until 1962, when a heart attack prompted him to retire from the burlesque business. "I couldn't carry on any longer," said Hakim, "The job took too many hours, I had to be there fourteen hours a day or longer to see that everything was going right." The property's owners also assumed that the theater would soon be razed by redevelopment.[94]

In 1955, Pete DeCenzi of San Francisco, owner of the El Rey Burlesque in Oakland, opened the New Star Theatre at 526 K Street, utilizing a former drugstore. Nestled behind a stately Bank of America branch at Sixth and K Streets, the New Star was managed by Ed DeVere. Despite the theater's less stellar reputation with police compared to the Lyric and Alameda, DeVere insisted in an interview with the *Sacramento Bee* that burlesque did not violate local blue laws:

> *Girls are forever popular and Sacramento's growing. I'm an ex-newspaperman myself, and I know the value of publicity. You've got to do it to get 'em in. It's no gold mine. All we get out of it is our salaries. But we run a clean show. I*

123

The Rio was a burlesque house until 1955 and reopened briefly in an attempt at "burlesque revival" in 1965, before being closed by the City of Sacramento. *Center for Sacramento History.*

don't see burlesque as something dirty. It's a graceful thing, an art. Someone once said it's the only truly American folk dance.[95]

Another burlesque house, the Rio at 519–21 J Street, also saw several lives. Originally operated from 1942 to 1955 as the Rio Theatre, the building reopened in the mid-1960s as the New Rio Follies. Manager Sam Goldberg considered the New Rio as part of a burlesque revival, not simply a venue for striptease but also for standup comedy and vaudeville-era stage performance. "Sacramento has always been a good burlesque town," Goldberg said. When interviewed by the *Sacramento Bee,* New Rio dancer "Dee Light" defended her choice of career:

Do I like burlesque? Well, let's say nobody's pushing me into doing it, so I guess I wouldn't be doing it if I didn't like it. I suppose the main thing is the money. My son has a nice bank account. I'm not a party girl, I go easy on the social life, you know? I mean I don't just run out and buy new clothes when the paycheck comes in. I've got to think about my boy…I consider myself a performer. Of course there are loose girls in the business, but they don't last. We just don't tolerate them. We have an image to think about…I've had years of ballet training, since I was 8. So has Maie Ling

The Sacramento Scramble

(a fellow dancer at the Rio). I mean, we both have the ability, but you just can't make any money as a dancer except in burlesque. The minimum is $300 a week. Lily St. Cyr, Tempest Storm, Blaze Starr and Irma The Body get about $1,000 and we get about $540. In other kinds of dancing you can't make that kind of money.[96]

Sacramento's city government disagreed with her assessment of the value of burlesque. In September 1965, Sacramento's police chief Joseph Rooney advised that the city council give the city assessor power to deny an application for a business license "whenever he deemed the operation to be contrary to city morals or welfare, whether for reasons of location, type of operation or character of the operators." Resulting action by the city council and police, as well as ongoing demolition of blocks in the West End during the era of redevelopment, brought an end to burlesque on K Street, but some of the small movie theaters switched to adult films, like the Times at Thirteenth and K. Like other Sacramento businesses, striptease clubs moved to the suburbs. By 1967, the entertainment section of the *Sacramento Union* carried ads for clubs like the Pink Pussy Kat A Go-Go on Greenback Lane and the Pagoda Lounge on Freeport Boulevard, advertising the same forbidden thrills as the Lyric or the Star had on K Street.[97]

THE LABOR MARKET

Along the waterfront, the westernmost end of K Street served a more utilitarian function than the bright lights of the business district. Since the 1863 groundbreaking of the Central Pacific Railroad, the river levee was railroad property. After the passenger depot was moved north to Second and H Streets and the riverboat dock was moved south to M Street, Front Street became a freight yard. A branch of the Southern Pacific Railroad, the Sacramento Southern, ran south along Front Street from the K Street freight depot, carrying produce from the Sacramento River delta farms. Many of the brick buildings constructed in the wake of Sacramento's early disasters and raised above flood level during the street raisings were converted to industrial uses.

Within an area of twenty-four blocks on the western end of K Street, about 5,000 migrant workers regularly inhabited Sacramento's Labor Market area, staying near the employment agencies that connected workers with farmers throughout the Sacramento and San Joaquin Valleys. Most

View from a hotel room window at Second and K Streets, the Labor Market. Across the street is the Brown & MacGregor employment agency, one of many hiring halls for agricultural laborers. Copa de Oro Restaurant, owned by Anita Molina, was located just past the corner of Second and J Streets. *Center for Sacramento History.*

farm work on California's enormous corporate farms was seasonal, and employment agencies like those in the Labor Market acted as middlemen to provide farmers with the labor they needed in peak months. According to a 1947 study by the City of Sacramento, 15 percent of all California's agricultural hiring was done in the Labor Market, filling more than 90,000 jobs each year, mostly during the summer and fall. During the rest of the year, these migrant workers sought any short-term labor they could find in canneries, mills, railroads or other places as opportunities appeared or simply passed time in the multitude of waterfront taverns, pool halls, barbershops and street corners. The 1930s brought homeless shelters and social services to the neighborhood for those who could not afford even the inexpensive boardinghouses of the Labor Market. Like many industrial waterfront neighborhoods, the foot of K Street was associated with poverty, crime and danger in addition to its economic functions.

The Sacramento Scramble

While the Progress and Prosperity Committee held sway farther east on K Street, ideas like civic improvement and urban beautification were secondary to the economically necessary but aesthetically unpleasant activities of industry along the waterfront. Smoke and soot from the smokestacks of industries, power plants and steam locomotives were nearly constant, and since many nearby industries operated twenty-four hours a day, the mechanical noises of factories and railroads were constant reminders of the area's industrial task. According to city surveys, most of the West End's inhabitants were older men, with one-fourth over the age of sixty-five and another quarter between fifty-five and sixty-four. There were many businesses in the neighborhood, one in three with an alcohol license. There were 167 bars in a twelve-block area. Some were open twenty-four hours a day to provide services for swing-shift and night-shift workers. A later city survey identified 218 recreational businesses (including bars, card rooms and pool halls), 91 service businesses (including shoe repair, employment agencies and barbershops) and 150 retail stores (including grocery, liquor, tobacco, pawnshops, drugstores, thrift and surplus stores). These businesses used the same buildings that once housed Huntington-Hopkins Hardware Store, the California State Supreme Court and the Hackett House. The neighborhood held a forbidden appeal for many young Sacramentans, who were warned to stay out by cautious parents and grandparents. Mike Munson recalls:

> *But once I got older, I wanted to see what I wasn't supposed to see. So when I was sixteen, seventeen, I didn't have a car but I would go with people who did have cars. Seedy was not the word to describe the west end. "Seedy" would be giving it a complement. Broken bottles, guys lying in doorways, sometimes you didn't know if they were alive, dead or drunk…As adventurous as I was, I didn't walk around there even in broad daylight. Back then the prostitutes were resplendent. Sac PD would put them in the wagon, take them across the bridge and drop them off in West Sacramento…That's what they thought of West Sacramento back then.*[98]

Most Labor Market inhabitants were single men, living in hotels, dormitories and rooming houses that often dated back to the gold rush and the days of the Central Pacific, including facilities like William Land's old Western Hotel. While many were migrant laborers or worked in nearby industries or businesses, others were retired or disabled older men whose limited means precluded any other housing. Some residents were transient,

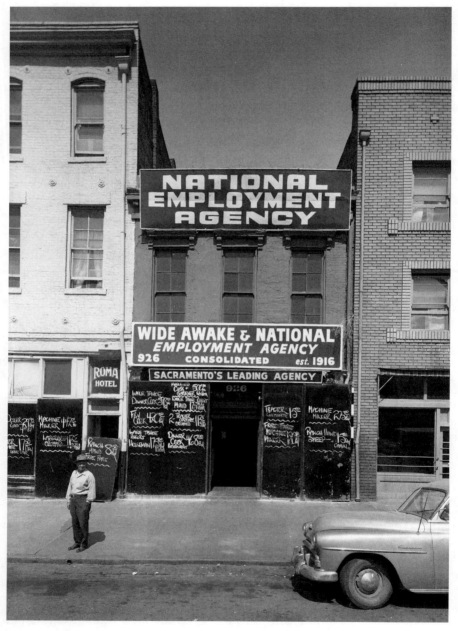

Hiring halls like the National Employment Agency at 926 Second Street provided labor to farms and industries throughout the Sacramento area. In between jobs, many laborers lived in nearby hotels, like the Roma (left) at 930 Second Street. *Center for Sacromento History.*

but by 1957, 60 percent had lived in the area a year or longer, and a quarter had lived there longer than three years. These residential hotels offered minimal accommodation, often simply a room with a bed, shared bathrooms and no kitchens. The large number of inexpensive restaurants in the West End kept these men fed, and the multitude of bars, cafés, barbershops, pool halls and card rooms provided entertainment and social space. Businesses in the Labor Market drew patrons and visitors from other parts of the city but depended on their regular clientele in the neighborhood.[99] "I'm sure people said 'Don't go to the West End,' but it was the neighborhood for me!" George Raya said. "It wasn't an unsavory place for hobos; it was where the family lived. It was just their Sacramento place—almost all Sacramento restaurants had living quarters in the back. They were inexpensive restaurants for working people."

Articles about the poor condition of the Labor Market and the West End in magazines like *Fortnight* were embarrassing to city government and the chamber of commerce, which responded to negative press with more positive, chamber-approved articles in magazines like *Motorland*. At the same time, the chamber and the city's newly formed redevelopment agency made plans not too different from the Progress and Prosperity Committee's 1908–1915 reports intended to remake Sacramento's waterfront in the "City Beautiful" image. These plans meant the end of the residential neighborhoods around K Street and a new identity for the business district.[100]

Chapter Six

The Shadow of the Alhambra

In Sacramento a homeless person walked up to us on K Street and said, "You know what you are? You're beautiful monsters." We loved that—that was just what we felt like. We felt like kings and queens in our world; we had made our own world because there wasn't another one for us.
—*Ivy Rorschach*

A 1965 study of Sacramento's shopping centers by graduate student Hansel Hope Cudgens found Sacramento's transportation network critically overloaded. Most vehicles entering the central city were through trips made by drivers whose destination was beyond the city's limits. Because the main highways through Sacramento ended on city streets running through town, every intercity driver added to traffic congestion downtown. Planners of the era looked for ways to move this traffic around the central city instead of through it.

In 1956, Sears became the first major department store to abandon K Street for the suburbs. In 1965, there were approximately 290 stores left in the downtown core around K Street, including 5 major department stores, which accounted for 25 percent of the city's sales tax revenue. This number had dropped from 342 stores in 1958, mostly clothing and home furnishings stores, accompanied by a decline in restaurants and movie theaters. When asked about the decline, merchants explained that most of the stores were smaller ones, dependent on foot traffic generated by the bigger stores that had moved away. Advertising to draw suburban customers was too

The Shadow of the Alhambra

K Street facing east from Ninth Street, circa 1965. The Alhambra Theatre, more than a mile away, is visible above the trees. *Center for Sacramento History.*

expensive for these smaller stores. Another consequence of redevelopment near K Street in the 1960s was a drop in sales in variety stores. These stores primarily catered to nearby residents, including those who lived in Chinatown, Japantown and the Labor Market. Without these downtown residents, the stores that served them no longer had customers.

After 1960, the number of downtown visitors dropped, accompanied by dropping retail sales. In 1954, the stores within two blocks of K Street generated 75.6 percent of the county's total sales tax. By 1965, K Street's share had plummeted to 19.6 percent of total county sales tax. In the same period, the five regional shopping centers increased county sales tax from 0.1 to 25.1 percent! Some downtown department stores, including Weinstock & Lubin and Hale's, opened suburban branch stores and saw their downtown sales figures drop while suburban stores did better business. The department stores without suburban branches were treading water or showing a slight increase but only because of expensive promotion to suburban customers.

Cudgens's study concluded that the K Street business district should be a convenience center for those living and working downtown and a regional center for specialty items that could not be found at regional malls, but K Street would probably never regain its place as the Sacramento Valley's

main shopping street. Another conclusion of the study was that suburban Sacramento's growth pattern to the south and east, away from the Sacramento River, left K Street and downtown on the western edge of the urban region. If the Sacramento region grew north of the American River and west of the Sacramento River in Yolo County, downtown Sacramento would once again be the hub of the region. Development pushing farther east left K Street on the urban perimeter. His final recommendation was a highway to accommodate the enormous quantity of cars passing through the central city.

In 1956, the Sacramento Redevelopment Agency sought a new department store to put in the West End and help draw traffic back to K Street, finally securing the attention of the national department store chain Macy's. The new Macy's opened in 1963 at Fourth and K Streets, atop the block formerly occupied by the old Weinstock & Lubin Department Store. This new tenant was brought to Sacramento by the promise of a new transportation network to bring suburban customers to their doorstep and to establish a new urban shopping experience to lure customers back to K Street.[101]

REDEVELOPMENT ARRIVES ON K STREET

Sacramento's earliest redevelopment plans began in 1947, based on expanding Capitol Avenue into a wider Capitol Mall and new office buildings for state government. The Sacramento Chamber of Commerce was involved in the early planning stages. The project was part of a greater redevelopment plan for the West End, focused on aesthetic improvements to Capitol Avenue, the main highway into Sacramento. Cities created redevelopment zones by defining them as "blighted," a term with exceptionally broad definitions. The term was used to describe areas in obvious disrepair, but it was also used to describe areas of low property value or properties whose buildings were considered obsolete. A blighted neighborhood was not necessarily a slum but a neighborhood with potential to become a slum. The term "blight" was a medical metaphor, like a form of infection or cancer, whose only cure was removal.[102] In 1949, the Federal Housing Act established policies to promote housing in redevelopment areas, a decision that made Sacramento's redevelopment plans easier to fund but divided proponents of redevelopment.

Public housing advocates favored this approach to replace substandard and crowded buildings. The Sacramento Chamber of Commerce strongly opposed it, an attitude shared by the United States Chamber of Commerce and the National Association of Real Estate Boards. They condemned the

The Shadow of the Alhambra

Demolition to make way for K Street's redevelopment revealed underground sidewalk spaces and the city's original ground floor. *Center for Sacramento History.*

1949 act as a socialist, big-government solution to the problem of housing and insisted that redevelopment was best suited to expand the commercial and business district. Public welfare and housing was best left in the hands of private enterprise. The chamber of commerce viewed downtown as a place to work and shop, not a place to live, since its earliest days of Progressive reform.

Sacramento's leadership initially included housing in the first West End redevelopment plans, released in December 1950, including rows of high-rise apartment buildings along the Sacramento River designed by architects Richard Neutra and Robert Alexander. This plan included luxury hotels and restaurants along the river adjacent to the new hotels, replacing entirely the old West End at the river end of K Street. However, the new director of the Sacramento Redevelopment Agency, Joseph T. Bill, felt that Sacramento's plan should not be based so strongly on housing, since, in his words, "Only about 700 families reside in this area, so relocation will not be difficult." The 1949 act mentioned that housing and relocation could be focused on family units but did not mention individuals. This created an excuse for Sacramento's redevelopment agency to avoid the need for replacement housing for the thousands of single men in the Labor Market. The redevelopment plan met resistance from the Chinese community, as many of the parcels in the proposed redevelopment area were owned by Chinese merchants and family associations. By 1952, the only redevelopment project completed was a public parking lot on L Street.

In 1954, the Eisenhower administration revised redevelopment law with less emphasis on public housing. This was interpreted as a more business-oriented view of redevelopment and was supported by the Sacramento Chamber of Commerce. On July 1, 1954, San Francisco real estate developer Benjamin Swig presented a redevelopment plan to the chamber of commerce and the city council. The plan suggested closing K Street to traffic between Second and Twelfth Streets, with a canopy down its center and moving sidewalks to carry pedestrians in both directions. No public housing was included in the plan. Like the suburban malls appearing in American suburbs, this was a mall for regional residents to visit, not a place to live.

The Swig plan was applauded by the chamber of commerce and opposed by West End residents, including the West Side Community Association, led by West End merchant Sal Anapolksy. Sacramento's city council proposed paying for the project with a bond issue, put before the voters in November 1954. The chamber of commerce advocated strongly for the bond and denounced its opponents, including West End residents and businesses, as opponents of progress and civic pride. Despite the support of the chamber and the city council, the bond measure failed to obtain the two-thirds majority necessary to pass.

After the failure of the bond issue, the Sacramento Redevelopment Agency provided a unique financing mechanism. By issuing its own bonds with returns guaranteed by the city, based on projected increases in the value of the land after redevelopment, the agency and the city could raise the money without requiring a public vote. The plan, called tax-increment financing, was promoted by city representatives as a way to pay for the project without a cost to taxpayers, the first use of tax-increment financing in the United States. The federal government approved the plan in May 1955, opening access to federal funds. The first redevelopment-related demolition took place on January 30, 1957, at 526 Capitol Avenue, adjacent to the old Zanzibar Club. The first phase of redevelopment focused on Capitol Avenue, envisioned as a grand entrance to the city and office building corridor, but the chamber of commerce, city government and Redevelopment Agency had other plans for K Street.[103]

In 1951, the year after the initial adoption of Sacramento's Urban Redevelopment Area Number 1 and creation of a redevelopment agency, a study recommended a pedestrian mall on Fourth and Fifth Streets between I Street and Capitol Avenue. In 1953, the City Planning Commission adopted a new redevelopment project area, Number 2-A, on K Street from

The Shadow of the Alhambra

Third to Fifth Streets, and made plans to remove traffic from that zone. By 1959, the pedestrian mall zone had expanded to Seventh Street as part of a third redevelopment zone. In 1961, the city council retained the firm of Skidmore, Owings & Merrill to plan a project then called West End Commercial Complex. This pedestrian mall was also part of the agreement to attract Macy's to K Street. Federal financing made the first street closures and the beginning of what later became Downtown Plaza possible. Two federal loans provided $23 million, two-thirds of the total project cost. The rest was paid by a special assessment on property owners.

Many American cities experimented with pedestrian malls during the 1950s and 1960s, often based on European precedents.[104] Plentiful federal funding, including federal loans and tax increment financing, combined with the desperate situation of many American urban downtowns, drove bold experiments in an effort to breathe new life into urban cores like K Street. Pedestrian malls were often based on a concept called the "superblock," turning multiple city blocks into a larger combined block with pedestrian traffic on the inner portions and vehicles around the perimeter. Superblocks, like suburban malls, kept pedestrians farther from fast-moving traffic and turned stores inward toward a common pedestrian walkway. The Downtown Association, an organization of retailers, property owners and businessmen, supported the concept, and in conjunction with the chamber of commerce, proposed a community center to function as an eastern anchor for the new downtown mall. This community center could host major events and conventions on the eastern end of downtown K Street, with Macy's as an anchor on the western end.[105]

In order to fund a municipal Convention Center, the city of Sacramento called a special election in 1963, asking citizens to vote on a $17,900,000 municipal bond to pay for the center's construction. The bond was defeated by a margin greater than 2 to 1. In June 1966, the city council held another special election, this time asking for only $12 million. This second bond proposal was defeated but by a narrower margin of 32,554 for and 41,614 against. Undaunted, in 1969 the Sacramento City Council formed a joint powers authority with the Sacramento County Board of Supervisors. This authority obligated the City and Sacramento County to guarantee rent payments for a convention center, authorizing a bond issue without voter approval. The convention center, originally located between Thirteenth and Fourteenth between J and L Streets, included a community theater and large convention hall with catering facilities. The main convention hall sat directly on top of K Street, creating a massive boundary between the pedestrian

Downtown Plaza under construction between J and L and Fifth and Sixth Streets. Beyond J Street, Chinatown redevelopment is underway. This photograph was taken from 555 Capitol Mall, an office tower built as part of Japantown's redevelopment plan. *Center for Sacramento History.*

Water features on the K Street Mall's western end, as seen here at Fourth Street, were intended to symbolize California's waterways. *Center for Sacramento History.*

The Shadow of the Alhambra

mall and the eastern half of K Street, still carrying automobile traffic from Fourteenth Street to Alhambra Boulevard.[106]

The first phase of the K Street shopping mall began in 1967 with the formation of Downtown Plaza Properties. This phase was a three-block pedestrian shopping center on K Street between Fourth and Seventh. This project incorporated the new Macy's store at Fourth and K Streets and demolished existing buildings on both sides of K Street and most along J and L Streets on those three blocks. The new low-rise mall enclosed shoppers, presenting its back to commuters on one-way J and L Streets. As blocks were demolished, they often found temporary use as parking lots, but as redevelopment projects occupied those lots, the developers built parking structures adjacent to the mall.[107]

K Street's redevelopment was part of a series of projects that effectively removed the entire population of the West End, including the Labor Market, Chinatown and Japantown. Some housing was built in the redevelopment zone, equal to about 25 percent of previous levels, but those who moved into this housing were generally not the same population that had moved out. Families were offered relocation assistance or replacement housing in other parts of the city, but the day laborers and migrants of the Labor Market were not. Early plans included a large dormitory-style building to house thousands of laborers with on-site hiring halls and recreation facilities, with preliminary sketches by architectural firm Dreyfuss & Blackford, but these plans never materialized and the lost housing was simply not replaced. Chamber of commerce representatives assumed that the market would provide sufficient housing for the 5,000 displaced workers, or those needing housing would move elsewhere. In practice, many shifted to Sacramento's homeless shelters and streets.[108]

In the summer of 1968, Interstate 80 was completed through Sacramento, including a portion running between Twenty-Ninth and Thirtieth Streets, crossing K Street a block west of the Alhambra Theatre. This highway connected to Interstate Highway 50 between W and X Streets and crossed the Sacramento River via the new Pioneer Bridge. The Tower Bridge lost its role as the main entrance to Sacramento as travelers were diverted around downtown. The end of 1968 brought Interstate 5 through downtown Sacramento, cutting directly across K Street. Most of the route ran between Front and Second Streets, weaving to the east between O and I Streets and sparing a six-block area closest to the waterfront. This route brought Interstate 5 between Second and Third Streets, obliterating many buildings like Huntington-Hopkins Hardware and the original office of the *Sacramento*

Bee. This belt of highways was promoted as a way to ease traffic congestion and make driving to downtown Sacramento easier. It also made downtown easy to leave, or avoid entirely.

In 1969, the contract for the K Street pedestrian mall between Seventh and Thirteenth Streets was awarded to A. Teichert & Son. Construction occurred through the summer of 1969, with a grand opening on December 6. The mall's grand opening was heralded with balloons, parades and public proclamations, bands playing on the new public promenades and a wave of curiosity-seekers eager to visit the stores.[109]

The mall featured a unique combination of landscape architecture and public sculptures, intended as a three-dimensional representation of the whole state of California along the length of the K Street pedestrian mall, designed by the firm of Eckbo, Dean, Austin & Williams, or EDAW. Project architect Jerry Loomis described the project for the *Sacramento Bee*: "It's going to be unique, not only in Sacramento but nationwide…We are pleased with the concept we have executed." Another member of the team, Steve Matson, described the interactive features of the mall: "We wanted to make as many things on the mall as we could that people could get involved in…We wanted to create objects that you could walk up to and walk through also." Some portions were designed as play areas specifically for children, but adults were just as welcome to explore and interact. Matson also said, "I hope people will say 'What the hell is this thing? Why is it out here?'"[110]

Despite the high expectations of the mall and a great deal of fanfare, reaction to the K Street Mall was not as strong as expected. A temporary surge in visitors helped sales tax figures, but K Street could not overcome the basic problems of a downtown shopping district in the era of suburban malls. The malls were closer to city residents, provided similar products and stores and were surrounded by free parking lots. Multiple city blocks were demolished to provide parking, but matching the size of a suburban mall parking lot was impossible, and thousands of commuting office workers competed with shoppers for parking spaces.

The population of the old West End had lost most of their housing, but many moved eastward into downtown hotels like the Marshall, Berry, Shasta and Sequoia (all of which escaped demolition). Other former West End residents slept on the streets and lived on the benches and parks of the new K Street mall. While burlesque clubs were no longer present, adult theaters and bookstores made K Street less family-friendly than its boosters hoped. Even the carefully designed landscape architecture failed to entice Sacramento visitors:

The Shadow of the Alhambra

Large angular sculptures on the mall's eastern end here at Eleventh Street symbolized California's mountains but soon gained the nickname "tank traps" for their similarity to concrete bunkers and obstacles. In this photograph, circa 1986, the sculpture is being demolished. *Center for Sacramento History.*

The mall was actually quite beautiful. It was a geological map of California, stylized. It had the mountains, and a sort of bluff that ran down the middle of the sidewalk, with flowers growing out of it. Beyond K it had the waters, waterfalls that shot water, that was north of California, a mountain range that ran on down to the deserts and to Baja. There was a canvas awning at Seventh, with a pavilion beneath it where they had musical events. But nobody in town knew it! For whatever reason, they didn't bother [explaining it.] *Most people didn't know what it was.*

Sacramento's K Street

Parking was a problem, street people [were] *a problem, bathrooms were, etcetera, so they tore it out. The theory at the time was, well yeah, they got to make money tearing it out, and more money for a new one. It was never clear to ordinary people why they tore it out in the first place, it was one of the most attractive malls in the country.*[111]

Despite the Herculean efforts to rebrand K Street, results were, at best, mixed. It brought attention and public financing to the urban core and radically reshaped downtown Sacramento, but it did not return K Street to its earlier prominence.[112]

The Counterculture Arrives on K Street

Sacramento's youth of the 1960s was already tuned into popular music via radio stations like KROY and KXOA, but in the mid-1960s a handful of radio stations started experimenting with free-form radio. In 1966, KXOA DJ Johnny Hyde hosted a one-hour Sunday night show called the *Gear Hour* dedicated to the era's musical experimenters. While Top 40 bubble-gum pop and even surf music were still wildly popular in Sacramento, the *Gear Hour* featured the surrealistic twangs of psychedelic rock.

Inspired by examples like KMET in Los Angeles and KSAN in San Francisco, Lee Gahagan obtained the license for a Sacramento radio station, KXRQ 98.5 FM. The station's broadcast tower was located on the thirteenth floor of the Elks Building at Eleventh and J Streets. Hiring a general manager, Ed Fitzgerald, and a few DJs, including Jeff Hughson, Charlie Weiss and Mick Martin, Gahagan started Sacramento's first free-form radio station, KZAP. On November 8, 1968, KZAP went on the air, first playing Jose Feliciano's rendition of "The Star-Spangled Banner," followed by the Beatles' "Revolution," to announce to Sacramento that a radio revolt had begun. Disc jockeys could play whatever they wanted without a playlist or strict musical format, as Charlie Weiss of KZAP describes:

We could play anything—and I mean anything...Segues were what we were about. From Olatunji into Oye Como Va, from Segovia into the Doors. The Beatles were constantly being played—all of their albums. But in addition to Hendrix, one would play a set of blues that could include the Mississippi Delta players to the Chicago guys. A Motown set was always fun. The mood of the music could move through several

The Shadow of the Alhambra

genres in an hour's time. There were message sets as well that could pass through folk, protest, Dylan, Jefferson Airplane and CS&N [Crosby Stills & Nash], *for example.*[113]

Many of the disc jockeys were avid music fans who brought their own record collections to play, and the radio station soon had a library as diverse as the DJs' tastes. Early KZAP advertisers included a local head shop located on Twenty-Second and K Streets owned by belly dancer and restaurant owner Jodette, but their first major advertiser was Tower Records, a regional record store chain that started in Sacramento and later grew to international prominence.

In May 1972, KZAP founder Lee Gahagan died. The new station owners allowed the DJs a greater level of flexibility than most radio stations, but the economics of attracting advertisers had higher priority. In 1973, the station moved from its peak atop the Elks Building to a new office located on the second floor at Ninth Street and J Street. That same year, the station introduced its new logo, a grinning Cheshire cat. Despite KZAP's physical descent, the station's popularity grew.[114]

Even as redevelopment and suburban expansion drained downtown Sacramento's population, some newcomers moved in. College students at California State University, Sacramento (also known as Sacramento State) found the neighborhoods around the eastern half of K Street convenient, a short bus or bike ride from school, and inexpensive. Many were also drawn by the neighborhood's architectural beauty and abundant tree cover, both legacies of the Progressive era homeowners, developers and landscape designers who built the neighborhood around the rebuilt Sutter's Fort.

The new K Street mall held some appeal for these young students. In 1973, Tower Records opened a new store on K Street featuring an elaborate psychedelic mural by rock poster artist Frank Carson. Nearby, a shop simply named Records opened, with an enormous quantity of used records and a store sign painted by famed counterculture artist Robert Crumb. In addition to the larger venues like Memorial Auditorium and Governor's Hall, local music promoters often used small theaters and other vacant spaces on K Street as live music venues. In 1968, Episcopalian priest Lee Page started Home Front, located inside St. Paul's Episcopal Church at Fifteenth and J Streets. Shows at Home Front featured local bands like the Blue Cheer (featuring members of Oxford Circle) and Big Foot, whose performances were enhanced by psychedelic light shows by Edison Lights (Jim Carrico and Don Nelson) and Captain Nemo. Carrico also drew psychedelic poster

art for Home Front shows. Home Front closed after the summer of 1968, but Page went on to open Weatherstone, a counterculture coffee shop at Twenty-First and H Streets. The Trip Room was another short-lived venue, located in the Native Sons Hall on Eleventh Street between I and J Streets, well known for its sprung dance floor. The Trip Room featured local acts like Public Nuisance and popular performers like Janis Joplin.[115]

Save the Alhambra!

In 1972, a group of Sacramento students, rock musicians, neighborhood advocates and Sacramento County supervisor Patrick Melarkey joined forces to save the Alhambra Theatre, the 1927 Moorish Revival picture palace that sat at the foot of K Street, from demolition. This struggle galvanized the community and bridged the generation gap with a series of rock 'n' roll shows and a vaudeville gala, the last events held at the Alhambra before the wrecking ball struck.

For years, the Alhambra had suffered economically from dropping attendance. In 1972, the property owner, United Artists, sold the theater to the Safeway supermarket chain for $485,000. After hearing community objections, Safeway was willing to sell the theater to the city for the same price it had paid. An early fundraising effort failed, but on September 20, 1972, the "Save the Alhambra" committee obtained a ninety-day court injunction against demolition. This gave the committee three more months to generate attention and funds. The benefit shows at the Alhambra were intended to do both.

The first show on November 9 featured local bands Steelwind and Standing Man. Local musician Jack Traylor used his connections with Jefferson Airplane's Grunt Records label, drawing well-known Sacramento and Bay Area acts to play the theater. Late publicity limited attendance at the first show, but later shows drew large crowds of 800 or more. The following Saturday, November 17, featured headliner Boz Scaggs. The next weekend included a Friday rock show headlined by Brotherhood Rush and a Saturday vaudeville and burlesque extravaganza on November 25. The burlesque show featured a performance by legendary fan dancer Sally Rand, who had also performed at the Alhambra on its opening night. A final show on December 1 featured Van Morrison and Vince Guaraldi. The Alhambra went out of business as a theater due to competition from suburban drive-ins and multiplexes, but its hundred-foot stage, large capacity and excellent

The Shadow of the Alhambra

The benefit shows to save the Alhambra drew large crowds of Sacramento youth, drawn by popular bands and the prospect of saving the theater for use as a community theater and rock venue. *Doug Taggart collection*.

acoustics made it an ideal concert hall for rock bands, and Sacramento lacked many mid-sized music venues. Other members of the "Save the Alhambra" committee saw it as a site for community theater, children's concerts and the Sacramento Symphony.

Despite these community efforts, the funds raised where not enough to pay Safeway's asking price. The Sacramento City Council was unwilling to provide the funds, having recently authorized $17.9 million in municipal bonds (a measure rejected twice by voters but finally authorized directly by the council) to pay for a new convention center. Some city council members claimed that using the Alhambra as a city-owned theater would compete with the convention center's planned community theater. Efforts to save the theater continued after the benefit shows. Local architects and engineers voiced their support to save the theater as a masterwork of architecture with a purpose and a future. In January 1973, a small group of supporters occupied the Alhambra in a sit-in that was removed by a court order. On January 11, 1973, a few days after the sit-in was removed, burglars broke into the Alhambra and stole statues, signs and other interior features from the theater

The final vaudeville show at the Alhambra featured the talents of Sacramentans who had performed at the Alhambra's opening night like Sally Rand and musicians of younger generations, like Mike Laws (right foreground), age nine. *Doug Taggart collection.*

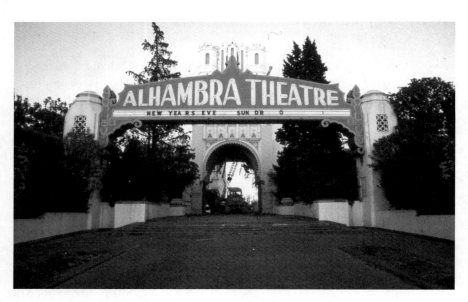

The fight to save the Alhambra failed but galvanized the community to protect other local historic places. Sacramento State journalist Doug Taggart documented the benefit shows and the theater's demolition. *Doug Taggart collection.*

The Shadow of the Alhambra

Support for the Alhambra was not universal. *Sacramento Union* editor Carlyle Reed criticized Patrick Melarkey for making irresponsible statements about Safeway, the planned Community Center Theater and the downtown Macy's. Reed framed his editorial as an apology to Sacramento's business community and claimed that efforts like "Save the Alhambra" gave Sacramento a reputation for "an unfriendly business climate."[116]

A final effort was made to put the matter to public vote, asking the citizens of Sacramento to back a bond for $1.5 million to purchase and restore the Alhambra. This vote was handicapped by its requirement of a two-thirds majority and the vote's scheduling during spring break, when many Sacramento State students (among the most vocal supporters of the Alhambra) were out of town. County supervisor Pat Melarkey attempted to submit a persuasive argument supporting the bond in the voter information booklet, but it was rejected because it was submitted minutes past the filing deadline. In a letter printed by the *Hornet* a week before the vote, Melarkey wrote:

> *There was a time when we all said Sacramento was a swell place to live, because it was close to everything. Right? Because we could live here, and go there…the mountains…the City…the oceans. Right…We just lived here. Right. Now people are thinking about really living here. Enjoying what Sacramento has. What we all have. That's called emerging community pride. We're starting to care about our town—making it a city—something to be proud of. Getting together to give our place focus—and meaning. That's what we're trying to do—the Committee to Save the Alhambra—save a building, a beautiful building, to remain a part of our heritage—to make it a continuing part of what our city is becoming. We want to save the Alhambra, because it belongs here—that it's something we can all enjoy, something to be proud of. That's why we're asking for your help.*[117]

On April 17, 1973, the vote to save the Alhambra failed, with 55 percent of voters opposing the bond. Demolition took months and was briefly interrupted when a large chunk of the theater collapsed on top of the wrecking crane. In September 1974, the new Safeway opened in the Alhambra's place. A fountain at the southern end of the parking lot and a few palm trees were all that remained. The fight to save the Alhambra spurred other efforts, including the city of Sacramento's first historic resources survey and a city landmark preservation ordinance, but

its loss denied Sacramento's rock bands and theater groups a venue in a city with too few to spare. The Alhambra became a symbol of K Street's lost architectural heritage and a lost opportunity for Sacramento's creative community, but it has never been forgotten.[118]

Beautiful Monsters: Lux Interior and Poison Ivy

In 1972, Kristy Wallace and Erick Purkhiser met while attending Sacramento State University. They shared an apartment at Twenty-First and H Streets above a laundromat, next door to the Weatherstone coffee shop. In Sacramento, Erick went by the name Vip Vop, and Kristy later adopted the name Poison Ivy Rorschach. Vip Vop later changed his name to Lux Interior when they founded the seminal psychobilly band The Cramps. Both were well known in Sacramento for their outrageous fashion sense, facilitated by local thrift stores and rock 'n' roll traditions, as Lux describes:

> But the great thing about Sacramento was the thrift stores. That's how we really started getting into this music—we would go into a thrift store and come out with a stack of 45s a foot high. They might sell for $50 or $100 each today, but we'd be buying them for a nickel. If they were a dime we'd be outraged, and if they were a quarter we'd be ready to break windows!

Poison Ivy added more:

> It wasn't like we already knew about a certain kind of music and were seeking it out; our attitude was more, "Gee, I wonder what this is?" We loved just discovering music. Not long after we met, this guy Ed at the K Street Mall opened a collector's record store that had amazing record covers on the wall. Before that, we used to go to another record store on the K Street Mall that had cut-out records for a quarter, so we already were into buying records we didn't know anything about—we'd make decisions just based on the cover, etc.[119]

In addition to record collecting and thrifting, both were part of Sacramento's youth music and counterculture scene. From their perspective, Sacramento's musical culture changed in the mid-1970s from a very active and glamorous place to a more conservative mindset, as Poison Ivy describes:

The Shadow of the Alhambra

We used to go to rock 'n' roll concerts and the crowd would look like a Fellini movie—everybody just dressed up wild. You could tell that every person there had taken all day to get ready, and the band was just one more decoration. But then Sacramento became downright macho; it seemed like every male had a beard and dressed like a farmer, and every woman looked like an "earth mother." You started hearing the same music on the radio—Crosby Stills & Nash and the Grateful Dead—and the same songs, not even their newest material. Sacramento became really oppressive—it got to the point where people would yell out of their car windows for how we looked. After Transformer came out we were real excited about going to see Lou Reed—we got tickets for the second row! But the show got canceled.[120]

According to Lux, only two rows of tickets were sold for the concert.

In 1973, Lux and Ivy moved to Lux's birthplace of Akron, Ohio, and formed The Cramps after moving from Ohio to New York. Their departure from Sacramento and their observations of the change in Sacramento's musical culture came during the same era as the demolition of the Alhambra and the decline of free-form radio at KZAP. The official reaction by city government and the chamber of commerce to the hippie counterculture was as strongly negative as their perception of K Street cruisers, West End burlesque dancers and Labor Market migrant workers. They were obstacles to a healthy business environment, aberrations to be removed from K Street lest their presence scare suburban visitors away from downtown Sacramento. According to Lux, police reaction to the counterculture was equally negative:

Besides being the hippie psychic capital of the world at the foot of Mount Shasta and everything, Sacramento also had the most uptight police force; it was considered an all-American city, so they got the money to "try out" all this really intense riot gear for use in other places. I had VIP VOP (an old Isley Brothers song) on my driver's license and every time I got stopped by the cops they would hassle me: "Vip Vop—I oughta give you a ticket just for that!"[121]

Demolition of the Alhambra signaled the end of an era on K Street. The chamber of commerce's vision of a pastoral city with a downtown dedicated to commerce alone, on the far edge of a growing valley of suburbs, eclipsed the industrial city and its critical location on the river. The new highways made K Street easy to reach, but they also made downtown Sacramento

Sacramento's K Street

K Street aerial, circa 1974. This photo shows Old Sacramento in the foreground, Interstate 5, Macy's, the pedestrian mall and the convention center. Partially redeveloped Chinatown is on the left, and the Safeway built on the Alhambra site is visible at the far end of K Street, just beyond the highway overpass between Twenty-Ninth and Thirtieth Streets. *Center for Sacramento History.*

The Shadow of the Alhambra

easy to leave or to avoid entirely. In the wake of this pastoral shift, those seeking greater urban vitality, like Lux and Ivy, moved away. Even the mighty Southern Pacific diminished in importance, and many assumed that railroads would follow the streetcars, riverboats and stagecoaches into history, along with K Street's jazz clubs and densely populated immigrant neighborhoods. Their passing was commemorated with plans for a railroad museum in Old Sacramento, like the Indian Museum on the far end of K Street that commemorated the vanishing Nisenan. Chinatown was replaced with a two-block redevelopment project incorporating Asian-themed architecture, while Japantown was completely destroyed, except for a VFW hall for Nisei veterans at Fourth and O Streets. Even the preserved and reconstructed portions of Old Sacramento, six city blocks surrounding the city's birthplace at Front and K Streets, were dedicated to the gold rush and completion of the Transcontinental Railroad, with little emphasis on the city's later history. The story of Sacramento's urban legacy was buried by Interstate 5 and the mall's interpretive sculptures, consigned to the memories of those who had once lived, worked and played on K Street.

Notes

1. Gunther Barth, *City People: The Rise of Modern City Culture in Nineteenth-Century America* (London: Oxford University Press, 1980), 15–26.
2. City of Sacramento 2030 General Plan, Historic & Cultural Resources Section (unpublished report, 2009).
3. Julian Dana, *The Sacramento, River of Gold* (New York: Farrar & Reinhart, 1939).
4. Bonita Louise Boles, "The Advent of Malaria in Sacramento," *Golden Notes* 36, no. 4 (Winter 1990).
5. Kenneth Owens, *John Sutter and a Wider West* (Lincoln: University of Nebraska Press, 1994).
6. Mark Eifler, *Gold Rush Capitalists: Greed and Growth in Sacramento* (Albuquerque: University of New Mexico Press), 19–37.
7. Ibid., 40–48.
8. Mead B. Kibbey, *Sacramento City Directory 1853–54*, 59–62.
9. Eifler, *Gold Rush Capitalists*, 50–53.
10. Joseph McGowan, *The Sacramento Waterfront 1848–1875* (Sacramento: Sacramento Museum and History Division, 1976), 13–17.
11. Walter Frame, "The Stagecoach Years," *Golden Notes* 6, no. 2 (October 1959): 4–8.
12. Barbara Lagomarsino, "Early Attempts to Save Sacramento by Raising Its Business District" (master's thesis, California State University, Sacramento, 1969), 3.
13. Ibid., 9; Steven Avella, *Sacramento: Indomitable City* (Charleston, SC: Arcadia Publishing, 2004), 39; Eifler, *Gold Rush Capitalists*, 98–100.
14. Lagomarsino, "Early Attempts," 16.
15. Ibid., 11; Avella, *Sacramento*, 40.
16. Kenneth Garner, "Blocks Burned by Fire of 1852," *Golden Notes* 18, no. 1 (March 1972).

17. K.D. Kurutz, "Sacramento's Pioneer Patrons of Art," *Golden Notes* 31, no. 2 (Summer 1985).
18. William L. Willis, *History of Sacramento County* (Los Angeles: Historic Record, 1913), 82–83.
19. Oscar Lewis, *The Big Four* (New York: Knopf, 1938), Chapters 2–5.
20. Robert O. Briggs, "The Sacramento Valley Railroad" (master's thesis, Sacramento State College, 1954).
21. Rudolph M. Lapp, *Archy Lee, A California Fugitive Slave Case* (San Francisco: Book Club of California, 1969).
22. Lagomarsino, "Early Attempts," 22; William M. Holden, *Sacramento: Excursions into Its History and Natural World* (Fair Oaks: Two Rivers Publishing, 1987), 197.
23. Lagomarsino, "Early Attempts," 26.
24. Ibid., 52–69.
25. Eugene Itogawa, "New Channels for the American River," *Golden Notes* 17, no. 3 (October 1971).
26. Lagomarsino, "Early Attempts," 132.
27. Philip Choy, *Canton Footprints* (Sacramento: Chinese American Council of Sacramento, 2008), 4–10.
28. Jean Pfaelzer, *Driven Out: The Forgotten War Against Chinese Americans* (New York: Random House, 2007), 26–29.
29. Melford S. Weiss, *Valley City: A Chinese Community in America* (Cambridge, MA: Schenkman, 1974), 46–48.
30. Pfaelzer, *Driven Out*, 101.
31. *Five Views: An Ethnic Sites Survey for California* (Sacramento: Department of Parks and Recreation, 1982).
32. Mae Ngai, *Impossible Subjects* (Princeton, NJ: Princeton Press, 2005), 204–206.
33. Lawrence Tom, *Sacramento's Chinatown* (Charleston, SC: Arcadia Publishing, 2010), 8–10.
34. Choy, *Canton Footprints*, 22; Dr. Herbert Yee, oral history interview, March 2012.
35. Ward McAfee, *California's Railroad Era, 1850–1911* (San Marino, CA: Golden West Books, 1973), 47–54.
36. William H. Gwinn, "The Freeport Railroad 1863–1865," *Golden Notes* 17, no.1 (April 1971).
37. McAfee, *Railroad Era*, 47–59.
38. Lewis, *The Big Four*, 254–255.
39. *Sacramento Record-Union*, July 5, 1880.
40. "Fourth of July," *Golden Notes* 18, no. 2 (July 1972): 1–9.
41. Rowena Wise Day, "Carnival of Lights," *Golden Notes* 16, nos. 2 & 3 (July 1970); Robert D. Livingston, "Illuminating Sacramento: Wells Fargo and the Sacramento Gas Co.," *Golden Notes* 27, no. 4, (Winter 1981).

42. George Mowry, *The California Progressives* (Chicago: Times Books, 1963), 85–89.
43. Ibid., 111–115.
44. Nathan Hallam, "The Historical Evolution of Sacramento's Central City Street Grid," (thesis, California State University, Sacramento, 2008).
45. Sacramento Street Fair and Trades Carnival brochure (Sacramento Chamber of Commerce, 1901).
46. Myrtle Lord Shaw, *A Sacramento Saga* (Sacramento Chamber of Commerce, 1946), 263.
47. Edith Pitti and Mary Praetzellis, *History of the Golden Eagle Hotel, 1851–1874* (Santa Rosa, CA: Sonoma State University, 1980).
48. Paula Boghosian, Historic Environment Consultants historic resources survey of Sacramento (unpublished survey, City of Sacramento, 1980).
49. Albert Flink, *A Century of Cinema in Sacramento, 1900–2000* (Sacramento: Andrew Flink, 2000), 15–22.
50. Shaw, *Sacramento Saga*, 187.
51. Charles Mulford Robinson, "The Improvement of Sacramento," (November 1908); John Nolen, "Del Paso Park, Sacramento, California," (December, 1911); Werner Hegemann, "Report of Dr. Werner Hegemann," (October 20, 1913) in "Sacramento City Planning Report," (unpublished document, repr., Sacramento Chamber of Commerce, 1929).
52. William Mahan, "The Political Response to Urban Growth: Sacramento and Mayor Marshall R. Beard, 1863–1914," *California History* 69, no. 4 (Winter 1990–1991).
53. Harre Demoro, *Sacramento Northern* (Berkeley, CA: Signature Press, 1991).
54. Jeffrey J. Moreau and David G. Stanley, *Central California Traction* (Berkeley, CA: Signature Press, 2002).
55. *Sacramento Bee*, September 16, 1907.
56. Sacramento Section, American Society of Civil Engineers, *The Western Pacific Problem* (Sacramento: American Society of Civil Engineers, 1945).
57. Boghosian, Historic Environment survey.
58. Willard Thompson, "David Lubin," Sacramento's Pioneer Merchant Philosopher," *Golden Notes* 32, no.1 (Spring 1986).
59. Harris Weinstock, "A Personal History of Weinstock, Lubin & Co. for the Cornerstone of the 1903 Store," *Sacramento History Journal* 5, nos. 2, 3, 4, (2005): 33–37.
60. Paul Groth, *Living Downtown* (Berkeley: University of California Press, 1994), 235.
61. Harris Weinstock papers, Bancroft Library, UC Berkeley.
62. Harris Weinstock, *Report on the Labor Laws and Labor Conditions of Foreign Countries in Relation to Strikes and Lockouts* (unpublished report, State of California, 1910).

63. Spencer C. Olin Jr., "Hiram Johnson, The Lincoln–Roosevelt League, and the Election of 1910," *California Historical Society Quarterly* 43, no. 3 (September 1966): 225–240.
64. William Mahan, "William Land: A History of the Man and the Park," *Golden Notes* 43, no. 2 (Spring/Summer 1997).
65. Willis, *History of Sacramento County*, 134–136, 803–806.
66. *Five Views*, 162.
67. Wayne Maeda, *Changing Dreams and Treasured Memories: A Story of Japanese Americans in the Sacramento Region* (Sacramento: Sacramento Japanese American Citizens League, 2000), 96–119.
68. Ibid., 118–123.
69. Ernesto Galarza, *Barrio Boy* (Notre Dame, IN: Univeristy of Notre Dame, 1971), 265.
70. Carolyn Mirich, *Crown Prince of the Whiskerinos* (Charleston, SC: BookSurge, 2006).
71. *Sacramento Bee*, "Doctors Say Knox's Decision Is a Just One," May 11, 1923, 2.
72. *Sacramento Bee*, "Liquor Raids in City This Month Hit Forty-Eight," January 19, 1928, 1; *Sacramento Bee*, "Five Places Raided by Federal Agents," December 17, 1928, 9.
73. Paula Boghosian, unpublished historic building survey of 708 K Street, Sacramento City Planning Department, 1981.
74. *Sacramento Bee*, "Liquor Is Seized at Capital Hotel; Warrant for August Ruhstaller," March 12, 1925, 27; *Sacramento Bee*, "Ruhstaller, Liquor Juror, Is Charged with Possession," March 13, 1925, 5.
75. *Sacramento Bee*, "Japanese Liquor Nabbed in Raid," December 8, 1925, 27.
76. John F. Burns, *Sacramento: Gold Rush Legacy, Metropolitan Destiny* (Dallas, TX: Heritage Media Corporation, 1999); *Sacramento Bee*, "City Finds Headache Hurts Just as Usual Despite Repeal and Real Liquors," December 6, 1933, 1.
77. Paul Frobose, "Sacramento's Golden Decade of Movie-Making," *Golden Notes* 38, no. 2 (Summer 1992): 9.
78. Ibid.
79. Flink, *Century of Cinema*, 30–36; John N. Wilson, *Brief Stories about Music and Musicians in Sacramento.* (Sacramento: John N. Wilson, 1980), chapter 11.
80. Maeda, *Changing Dreams*, 164–165; George Yoshida, *Reminiscing in Swingtime: Japanese Americans in American Popular Music, 1925–1960* (n.p.: National Japanese American Historical Society, 1993), 25–29, 67–78.
81. Choy, *Canton Footprints*, 100; interview with Tom family member by author, March 2012.
82. Portuguese Historical & Cultural Society photo records; Dolores Silva Greenslate (archivist at the Portuguese Historical & Cultural Society), interview with the author, April 2007.
83. Buddy Baer, *Autobiography of Buddy Baer* (Claremont, CA: Rhino Records, 2003).

84. Clarence Caesar, *An Historical Overview of Sacramento's African American Community* (thesis, California State University, Sacramento, 1985); Keith Burns, interview with the author, February 2012.
85. Guphy Gustafson, "Farm Fresh: Sacramento's Country Music Legacy," *Midtown Monthly* (September 2011): 44–45; Bruce Tucker, "Tell Tchaikovsky the News: Postmodernism, Popular Culture, and the Emergence of Rock 'N Roll," *Black Music Research Journal* 9, no. 2 (1989); "Billy Jack Wills Show," http://archive.org/details/otr_billyjackwills, accessed April 2012.
86. George Raya, interview with the author, February 2012.
87. Mark Gaffney, "Presentation to Sacramento County Historical Society," November 2010. Audio recording, Sacramento County Historical Society.
88. George Raya, Maryellen Burns and Mike Munson, interviews with the author, February–April 2012.
89. "Traffic Division Chief P.J. Bennett," *Police and Peace Officers' Journal* (November–December 1947): 10, 43–45; "Traffic Better in Sacramento," *Police and Peace Officers' Journal* (November–December 1947): 55.
90. "Sacramento Scramble," *Police and Peace Officers' Journal* (May 1952): 13–32.
91. Tim Foster, "Hot August Knights," *Midtown Monthly*, September 2008, http://www.midtownmonthly.net/life/hot-august-knights/
92. George Raya, Maryellen Burns and Mike Munson, interviews with the author, February–April 2012.
93. "KROY Radio," http://www.1240kroy.com, accessed May 2012; Alex Cosper, "1240 KROY," http://www.playlistresearch.com/sacradio-kroy.htm, accessed May 2012; Dennis Newhall, "Sacramento Rock &Radio Museum," http://www.sacrockmuseum.org, accessed May 2012.
94. *Sacramento Bee*, "The 'Alameda Lovelies' Take Closing Bow," July 11, 1962.
95. James J. Brown, "Looking Around," *Sacramento Bee*, January 24, 1960.
96. *Sacramento Bee*, "'Ritual' of Burlesque Returns to Capital Stage," September 5, 1965.
97. *Sacramento Bee*, "Burlesque or Not? City Council Will Decide," September 24, 1965, C1; Advertisements, *Sacramento Union*, January 13, 1967, B11.
98. Mike Munson, interview with the author, April 2012.
99. Howard B. Leonard, *Relocation Profile: The Final Relocation Report on Project No. Calif. R-18—Capitol Mall Extension* (unpublished, Redevelopment Agency of the City of Sacramento, 1964); Davis McEntire, *Relocation Plan: Slum Area Labor Market, Sacramento* (unpublished, Redevelopment Agency of the City of Sacramento, 1959).
100. "City of Sacramento: Senile and Satisfied," *Fortnight* (September 15, 1954); "Sacramento: In the Center of Our California Heartland," *Motorland* (March/April 1955).

101. Hansel Hope Cudgens, *The Impact of Sacramento's Suburban Shopping Centers on Her Central Business District, 1966* (thesis, California State University Sacramento, 1966), 31–56, 69–76.
102. Robert Fogelson, *Downtown: Its Rise and Fall, 1880–1950* (New Haven: Yale University Press, 2001), 347–349; Kenneth Jackson, *Crabgrass Frontier: The Suburbanization of the United States* (New York: Oxford University Press, 1985), 212–230.
103. Brian Roberts, "Redevelopment at the Crossroads: How Sacramento City Chose Between Priorities in the 1950s," *Golden Notes* 35, no. 2 (Summer 1989).
104. Roberto Brambilla and Gianni Longo, *For Pedestrians Only* (New York: Whitney Library of Design, 1977).
105. Sacramento Redevelopment Agency, "A Decade of Community Planning for Pedestrian Malls in the West End Redevelopment Area" (unpublished report, April 10, 1962).
106. Carolyn Johnson, "Citizens Want Alhambra, Get Convention Center," *Sacramento State Hornet*, October 4, 1972, 5.
107. *Sacramento Bee*, "Flight to Suburbs Added Urgency to Need," December 5, 1969.
108. Leonard, *Relocation Profile*; McEntire, *Relocation Plan*; Roberts, "Redevelopment" 11–14.
109. D.F. Stevens, "K Stereet Mall Traffic Bulletin No. 2" (unpublished document, City of Sacramento, May 16, 1969) *Sacramento Bee*, "Downtown Plaza Mall Opens with Rites, Customers," December 7, 1969.
110. *Sacramento Bee*, "Planner of 'Fastest Mall in History' Seeks 'Involvement' in 'Tilted Planes,'" December 5, 1969.
111. Leo Dabhagian, interview with the author, March 2012.
112. Brambilla and Longo, *For Pedestrians Only*, 136–139.
113. Alex Cosper, "The Legend of KZAP," http://www.playlistresearch.com/kzap.htm#early.
114. Ibid.
115. Michael Pierce, e-mail to the author, April 2012; Dennis Newhall (curator at Sacramento Rock & Radio Museum), interview with the author, May 2012.
116. Carlyle Reed, "Melarkey Shows Irresponsibility," *Sacramento Union*, March 30, 1973, A2.
117. Patrick Melarkey, letter to editor, *Sacramento State Hornet*, April 11, 1973.
118. Dennis Newhall (curator at Sacramento Rock & Radio Museum), interview with the author, July 2011; Doug Taggart, interview with the author, September 2011; *Sacramento State Hornet* articles, various dates, Fall 1972–Spring 1973 semesters.
119. Andrea Juno and V. Vale, *Incredibly Strange Music*, vol. 1 (San Francisco: RE/Search, 1993), 6–12.
120. Ibid.
121. Ibid.

Index

A

Alameda Theatre 122, 123
Alhambra Theatre 10, 90, 137, 142, 143, 145, 146, 147
American Cash Apartments 56
Archy Lee 26, 27, 28

B

Baer, Buddy 100
Baer, Max 83, 100
Beard, Marshall 59
Bennett, Daniel J. 117
Bigelow, Hardin 20, 21
Brannan, Sam 16, 20, 34, 48
Breuner's Furniture 55, 86, 111, 113, 116, 119
Burnett, Peter 17, 18, 27

C

California State Fair 41, 44, 45, 47, 53, 67
California State University Sacramento 141
Carraghar, Edward James (E.J.) 59, 62
Central California Traction 60, 62
Central Pacific Railroad 31, 39, 40, 41, 44, 48, 55, 65, 125, 127
China Slough 31, 34, 76, 81. *See also* Sutter Lake
Chinatown 34, 36, 73, 97, 131, 137
Clark, George 50
Clayton, Marion 69
Clayton, Sarah 69, 71
Clunie Theatre 56, 88
Country Maid Restaurant 121
Crest Theatre 113
Crocker, Charles 22, 40
Crocker, Edwin Bryant 22, 24, 27, 28, 44, 66
Crocker, Margaret 66

D

Days of '49 76, 78

E

EDAW 138
Elks Building 100, 140
Empress Theatre 58
Esquire Theatre 116
Eureka Club 102

Index

F

Fanchon & Marco 88, 92
flood 107
Fong, Mabel 95

G

Gaffney Display Company 113
Galarza, Ernesto 73
Gallatin, Albert 46, 66
George McDougal 16, 17
Golden Eagle 55
gold rush 16, 26, 33, 34, 53, 54, 55, 58, 81, 86, 121, 127

H

Hakim, Nadra "Ned" 122, 123
Hale's Department Store 66, 86, 88, 111, 131
Hammond, E.P. 59
Hastings, Lanford 16, 17, 18
Hegemann, Werner 58
high-graders 31
Hippodrome Theatre 58, 88
Hoffman, Ancil 82, 100
Hopkins, Mark 24, 25, 37, 38, 39, 59, 66, 127, 137
Hopley, Nettie 73
Horribles, the 41, 42, 43

I

Inada, Betty 90
Interior, Lux 146
Ivy, Poison 146

J

Japantown 71, 72, 73, 90, 91, 94, 109, 131, 137
Johnson, Hiram 50, 68
Judah, Theodore 26, 39

K

KFBK 97, 105, 120
Kress Department Store 111
KROY 97, 120, 140
KXOA 121, 140
KZAP 140, 147

L

Labor Market 125, 127, 129, 133, 137, 147
Land, William 55, 68, 69, 91, 127
Lubin, David 65, 67, 74
Lubin, Simon 67, 74
Lyric Theatre 110, 122, 123, 125

M

McClatchy, James 20
McClatchy, Valentine 63
Melarkey, Patrick 142, 145
Miyakawa, Agnes 92
Miyakawa, Tsunesaburo 73, 92
Moore, Alex 102
Moore, Hovey 102
Murata, Elizabeth 91, 92

N

Nippon Theatre 73, 122
Nisenan 13
Nolen, John 58

O

Oakland, Antioch & Eastern 60
Oak Park 44, 58, 61, 69, 91, 113
Okumoto, Richard 91

P

Pacific Gas & Electric. *See* PG&E
Parker, Charles W. 27
Peltier, George W. 63, 88, 90
PG&E 46, 60, 61, 69
Plaza Park 21, 31, 46
Progress and Prosperity Committee 58, 127, 129
Progressive 11, 65, 69, 81, 133, 141
Pullman Strike 43, 49, 67

INDEX

R

Rand, Sally 90, 142
Raphero 16
Republican Party 24, 38, 39
Rio Theatre 124
riverboat 20, 21, 33, 41, 60, 83, 107, 125
Robinson, Charles Mulford 58
Roos Brothers Department Store 113
Roxie Theatre 113
Ruhstaller, August 83

S

Sacramento Chamber of Commerce 50, 51, 53, 58, 59, 63, 64, 65, 69, 76, 79, 86, 87, 106, 121, 129, 132, 133, 134, 135, 137, 147
Sacramento Electric, Gas & Railway Company. *See* PG&E
Sacramento Northern Railway 61. *See also* Northern Electric
Sacramento Redevelopment Agency 132, 133, 134
Sacramento Valley Railroad 26, 29, 39, 44
Saddle Rock Tavern 62
San Francisco 15, 17, 20, 21, 22, 24, 28, 33, 36, 38, 39, 41, 46, 48, 50, 56, 59, 60, 64, 65, 67, 82, 95, 104, 107, 115, 140
Schaw, William 63
Sellon, George 56
Senator Theatre 88, 121
Sequoia Hotel 56, 138
Silveira, Gabriel 97, 120
Southern Pacific. *See* Central Pacific
Southern Pacific Railroad 43, 46, 49, 50, 58, 59, 60, 62, 63, 64, 67, 81, 86, 109, 110, 125
stagecoach 19, 26
Stanford, Leland 24, 25, 37, 38, 39, 59, 65
Starks, Leonard 88

Star Theatre 123
State Theatre 113
steamboat 19, 87
Stovall, Charles 27, 28
streetcars 44, 45, 46, 47, 54, 59, 60, 61, 62, 64, 66, 107
Sutter, John 13, 17, 20
Sutter, John, Jr. 17

T

Thompson, Vincent "Ted" 102
Tom, Wayne 94, 116
Tower Records 141
Tvede, Helen 100

W

Warren, Earl 56, 116
Weinstock, Harris 59, 65, 67
Weinstock & Lubin 45, 113
Wells Fargo Express Company 20
West End 86, 104, 110, 115, 116, 125, 126, 127, 129, 131, 132, 133, 134, 135, 137, 138, 147
Western Hotel 55, 68, 127
Western Pacific Railroad 62, 63, 64, 65, 79
Whiskerinos 78
White, Clinton L. 59, 63
Wills, Billy Jack 104, 105
Wills, Bob 104
Wilson, Charles Lincoln 26

Y

Yee Fow 34, 37
Yee Fung Chung 37, 53

About the Author

William Burg was born in Skokie, Illinois, and grew up in the suburbs of Sacramento. Since 1993, he has lived in Sacramento within strolling distance of K Street. This is his fourth book about Sacramento's urban history, in addition to approximately fifty articles and essays published in *Midtown Monthly Magazine* and *Sacramento Press*. He has served as president of Sacramento County Historical Society and the Sacramento Old City Association, studied public history at Sacramento State University and works as a historian for the State of California.